Cup of Life
BOOK CAFÉ
ON THE MALL GERALDTON
9965 5088

Geraldton July 2005

Dear Sr Anthony,

After having heard about your love of Tazmania and also knowing your love of trees I thought this would be the best book for you. Thank you very much for the warm welcome, I had the best time it was great meeting again. Happy Golden Jubilee too and all the best for the future. Love Edouard H and family.

TARKINE

TARKINE

Edited by Ralph Ashton

A Sue Hines Book
ALLEN & UNWIN

First published in 2004

Copyright text © individual writers 2004
Copyright photography © individual photographers 2004

All rights reserved. No part of this book may be reproduced or transmitted in any form or by any means, electronic or mechanical, including photocopying, recording or by any information storage or retrieval system, without prior permission in writing from the publisher. The *Australian Copyright Act 1968* (the Act) allows a maximum of one chapter or 10% of this book, whichever is greater, to be photocopied by any educational institution for its educational purposes provided that the educational institution (or body that administers it) has given remuneration to Copyright Agency Limited (CAL) under the Act.

A Sue Hines Book
Allen & Unwin Pty Ltd
83 Alexander Street
Crows Nest NSW 2065
Australia
Phone: (61 2) 8425 0100
Fax: (61 2) 9906 2218
Email: info@allenandunwin.com.au
Web: www.allenandunwin.com

National Library of Australia
Cataloguing-in-publication entry:

 Ashton, Ralph.
 Tarkine.

 ISBN 1 74114 354 3.

 1. Wilderness areas - Tasmania, North-western - Pictorial
 works. 2. Tarkine Region (Tas.) - Pictorial works. I.
 World Wide Fund for Nature Australia. II. Title.

919.465

Cover, text design and typesetting by Phil Campbell
Digital map data for the maps on page 140 is courtesy of the Commonwealth of Australia and the Tasmanian Department of Primary Industries, Water and Environment.
The maps were redrawn by Phil Campbell.
The paper used in this book is sourced from sustainably managed European forests.

Printed in China by Everbest

10 9 8 7 6 5 4 3 2 1

Contents

Foreword — Robert Purves … 1

Saving The Tarkine — Tim Flannery … 2

Photographing the Land — Les Walkling … 6

A Community of Artists — Ralph Ashton … 7

The Photographs … 11

The Fortnight … 138

The Tarkine Maps … 140

Photographers' Credits … 141

Writers' Credits … 150

Biographies … 151

Acknowledgements … 154

Foreword

My motivation for the creation of this beautiful book is simply to showcase this awe-inspiring, largely unknown part of Australia – a wilderness that has survived, virtually untouched, for over 65 million years from its Gondwana heritage, but which is today under increasing threat from man.

It is remarkable that in Australia, the driest inhabited continent on earth, we have one of the world's largest temperate rainforests. For me, the unparalleled beauty and grandness of the Tarkine places it up there with other great Australian natural wonders: the Great Barrier Reef, Arnhem Land and the dramatic arid landscapes such as the MacDonnell and Flinders Ranges.

As a fifteen-year-old, I visited Lake Pedder as the floodwaters were rising. With Olegas Truchanas' iconic images fresh in mind, I was devastated by the finality of its senseless destruction. It was a defining moment for me: I fell in love with Tasmania's natural beauty. In the ensuing thirty years, I have made many expeditions to Tasmania's wilderness, and Truchanas' seminal photographic essay has been ever-present on the coffee table in my living room.

In 2001 I visited the Tarkine for the first time, bushwalking deep into the forest and exploring along its wild coastal edge. I was struck by the same sense of awe and imminent loss as I'd experienced at Lake Pedder. I could not stomach the thought of history repeating itself, and was determined to do everything I could to prevent it.

But I realised that to arouse the passion of a nation, we had to bring the inaccessible beauty of the Tarkine to a wider audience. With the Truchanas book in mind, the obvious course of action was to carry on the spirit and tradition of Tasmanian wilderness photography. The idea for this book took hold.

When looking at this book I am sure you will feel that the Tarkine is a breathtaking place. It is an incredibly complex, ancient and untouched rainforest, flanked by a wild and jagged coast, vast sand dunes and enfolding magnificent fields of button grass in a landscape that can consume and inspire the human spirit.

The book is a tribute to the many talented photographers and writers who participated in the project, including some of Australia's great landscape photographers as well as young up-and-coming Tasmanian photographers who gave of their time and talent. This is their book and a reflection of their desire to share these powerful and beautiful images with the world – the Tarkine's mystical beauty in all its shapes and moods.

Finally, I wish to say a special thank you to Ralph Ashton, who has shared the vision of this vital project and whose tireless energy and considerable skill made this book a reality.

I hope you are touched by this book and will want to champion the cause to preserve this amazing part of our natural heritage.

ROBERT PURVES
PRESIDENT, WWF AUSTRALIA

Saving the Tarkine

The Tarkine? It's a forest in Tasmania, isn't it? That was my response when Rob Purves, president of WWF Australia, asked if I knew the place and wished to help save it. There are so many forests that need saving in Tasmania – the Styx and those growing in the valley of the Florentine, to name just two. So, I thought to myself, what's so special about the Tarkine?

That question was answered for me when the opportunity came to visit this most inaccessible of Australia's forested regions. The only way to many parts of it is by helicopter, so one cool summer day in 2004 I set off from Launceston, heading for the Tarkine and the remote west coast of Tasmania, and into what was to become one of the most deeply moving experiences of my life.

For the first three-quarters of the journey we flew along the foothills of the ranges that rise from the northern Tasmanian coastal plain, and what we saw below us raised some serious questions. Forestry plantations on an industrial scale were unconditionally upheaving the landscape, the orderly plantations of radiata pine, blue gum and shining gum stretching out below us as far as we could see, swallowing a good deal of grazing land and native forest as well. Most of the plantations were young, with many large bare patches yet to be planted or newly planted, and these most often had been bulldozed into the stands of old eucalypts and temperate rainforests, with what was left clinging to the higher peaks and steepest valleys. The entire region – one far larger than the Tarkine itself – had been utterly transformed by the frenzied and seemingly accelerating agro-forestry activity of the past few years.

Yet then we reached the valley of the Arthur River, and beyond – for as far as the eye could see from our eagle's perch – stretched the Tarkine: a sea of virginal forest, heath and button grass plains that spreads over nearly half a million hectares; all the way from the inland ranges to the wild west coast. The rainforest was then at its prettiest, for towards the end of summer the leatherwood trees flower, lighting up the normally sombre temperate forest with great swathes of brilliant white. At several centimetres across, the flowers of these ancient Gondwanan trees are surprisingly large, their brilliant white petals forming an irresistible attraction to the honey-bees that are brought to the edges of the Tarkine every year to create some of the most delicately flavoured honey on Earth. Even the sombre Antarctic beech, towering above all with their dense, dark-green canopy, are enlivened by the summer warmth, taking on shades of lime green and copper as their new growth spreads. In crossing the Arthur River we had clearly entered another world, one where the scream of the chainsaw and roar of the logging truck are yet to be heard, and hopefully never will.

The forests containing those leatherwood and Antarctic beech trees form the single largest patch of temperate rainforest in Australia, and one of largest temperate rainforests in the world. Nourished by fertile basalt-derived soils and around three metres of rainfall per year, its 177 000 hectares spreads in river valleys and on plateaux in a broad band roughly parallel to the coast.

The Tarkine is home to a great variety of vegetation types in addition to rainforest, for it is a geologically diverse region whose underlying rock types and the mineral products they yield as they weather to soil dictate the nature of the vegetation that can be supported. Where old volcanoes have brought basalts and dolerites to the surface, rainforests thrive, but where quartz-rich deposits (mostly quartzites) and rocks formed of the ancient oceanic crust (ultramafics) crop out, button grass or heath predominate.

The grandeur of the region is best appreciated from the summit of Mount Bertha, an isolated peak that stands over 700 metres above sea level in the midst of the Tarkine. The mountain is crowned with a wreath of button grass and heathland that is prime habitat for both wombats and white-lipped snakes, which abound on its summit. In summer the silver banksias are flowering, as are the tea-trees and myriad other stunted shrubs, bringing a gentleness to what must often be a forbidding landscape, metres deep in snow at times.

Yet all around, in the Savage River and Arthur River drainages, can be seen the glorious temperate rainforest, and it is this vegetation that is at the heart of contention in the Tarkine. Fed by fertile soils and a relatively temperate climate, the Antarctic beech growing there reach their full potential, soaring forty metres or more from the forest floor, and extending more than a metre across the bole. The basalt soils are also thought to lend their wood a rich pinkish-red hue. Known in the trade as red myrtle, the timber of this ancient Gondwanan relic brings a premium to timber-getters, and is keenly sought after. But the trees grow slowly – too slowly to reward planting – so the only economic supply on Earth lies in the ever-diminishing wild forests of Tasmania.

For more than twenty years a moratorium on logging has been observed in the Tarkine's epicentre, but this was lifted by the Tasmanian government in June 2003, and now the forestry industry has its eye on the heart of the Tarkine – a region thirty

kilometres long by around ten kilometres broad and containing the best of the Antarctic beech rainforest.

Today the full life cycle of these timeless forests can still be seen in the region. Groves of giants are punctuated here and there by an opening in the canopy where some superannuated individual has given way, and in crashing to the ground has created the opportunity for tree-ferns and saplings to flourish. The enormous, mouldering trunks of the these fallen trees can be seen decades after they fall, until a covering of moss and their propensity to act as a nursery for younger trees finally obscures their outline. It is this cycle of forest life, and the diversity it brings, that is lost to logged forest. Ten thousand years of complex patterning and growth is brought to a halt by the bulldozers, and the biological diversity it fostered is consumed in an instant.

As relatively undisturbed ecosystems, the Tarkine's temperate rainforests are of exceptional value. Those lying around Mount Bertha comprise perhaps the least disturbed forest in all of Australia — the closest thing our continent offers to a true wilderness. The first European to enter it — perhaps the first human ever to see parts of it — was surveyor Jorgen Jorgensen, who said of it in 1827, 'It is a question whether ever human being either civilised or savage had visited this savage looking country. Be this as it may, all about us appeared well-calculated to arrest the progress of the traveller, sternly forbidding man to traverse those places which nature had selected for its own silent and awful repose.' Not one in ten thousand Australians has set foot in the rainforests of the Tarkine, and doubtless the overwhelming majority of us never will. Yet it is critically important that the region be left as it is, for here we can witness the workings of nature as they have operated, undisturbed by the hand of man, for millennia. And simply knowing that such a place exists is a rare and great privilege in this increasingly crowded world.

One of the most striking things about the Tarkine region is the almost complete absence of weeds and feral pests (including the introduced trout, which has not been sighted during recent surveys). Instead one finds a magnificent diversity and abundance of native species, of which fifty-six are listed as rare, threatened or endangered. Among the most important in terms of biodiversity conservation are the endangered ground parrot and critically endangered orange-bellied parrot, of which only 200 survive. The Tasmanian form of the wedge-tailed eagle (which is slightly larger than the mainland form) is also common in the region, as is the grey goshawk and hooded plover. The marsupials also abound, with quolls, devils, wallabies, pademelons, wombats and possums all being present, often in high densities. As the town of Corinna on the Tarkine's southern margin indicates (its name comes from a Tasmanian Aboriginal word for the thylacine) the thylacine was once abundant in the region and remained common there until the 1920s.

Many treasures are found among the region's invertebrates as well, including a plethora of worms, which are admittedly not everybody's cup of tea, yet are vital to the working of the ecosystem. Five native species of earthworms plough the Tarkine's soil, while among the more showy varieties are a velvet-worm, two species of leeches and the bizarre proboscis worm, the only land-based nemertean worm recorded in Tasmania. For those whose tastes do not extend to worms, perhaps more arresting is the news that the largest freshwater crayfish in the world (*Astacopsis gouldi*) has its last stronghold in the streams of the Tarkine, and north-west Tasmania. It is a true giant, reaching a metre in length, but sadly it too is endangered.

The Tarkine takes its name from the clan of Tasmanian Aboriginals who lived in and managed the region for millennia. They traversed stretches of country from the Arthur River (which forms the Tarkine's northern border) south to the Pieman River (which forms its southern border, close to the northern boundary of the famed Tasmanian Wilderness World Heritage Area). As close to pristine as any of the few remaining truly wild places in the world, it is indisputably unique and irreplaceable. If the Tarkine were to be joined to the world heritage area, a vast reserve would be created, stretching from just a few kilometres south of Tasmania's north coast all the way to its southwestern extremity. If this were to happen, it would, in my opinion, be among the top half-dozen natural areas remaining in the world. And properly managed, it would bring wealth to Tasmanians into the foreseeable future.

To the west of the rainforests lie vast heathlands, and nearer the coast, sand dunes, between which are closely cropped, emerald-green marsupial lawns. This area was the base-camp to the Tarkiner clan who, although they traversed much of the Tarkine, concentrated their activities along the coast where seals, abalone and seabirds abounded. The forests of the interior were clearly less frequently visited, and large areas may never have been entered at all. Some forest, however, was frequented, particularly where spongolite stone (a valuable resource for the Aboriginals) lies under the sombre canopy, and the hunters and gatherers who visited this particular area doubtless sought out plant materials and wallabies there too.

The abundance of middens clearly indicates that the ocean beaches and headlands extending from Sandy Cape south to the mouth of the Pieman River were a favoured resort of the clan. Dark clouds can roll in off the Southern Ocean for weeks on end in this region, bringing drizzling rain and bitter cold. We might wonder how human beings survived the winter in such a place. Yet evidence abounds that not only did people survive there, they developed a vibrant and unique culture in this windswept spot.

If ever you are blessed with the opportunity to visit this wild place – indisputably one of the most inaccessible coastlines in Australia – tread carefully. At your feet you might find a cluster of abalone shells weathering out of the sand. Some day long ago, every one of them was prised from its rock by a Tarkiner woman, who dived in the roiling, frigid Southern Ocean that rages before you, equipped with little more than a stick, flattened at one end, for use as a wedge. When she had a dozen or so of these delicious molluscs, she would leave the freezing water and walk to where you now stand. Perhaps she warmed herself by a fire, set in the lee of the dune, as she fed her family with this prince of seafoods. And then, when the meal was finished, the Tarkiners placed those shells exactly where you see them today. Perhaps you can picture in your mind's eye where that family sat – how they arranged themselves around that long-cold fire?

A thousand similar stories can be read in the dunes at Sandy Cape. Great drifts of small mussel shells tell perhaps of lean seasons, when the abalone were not accessible, while the bones of seals and wallabies are the last record of successful hunts. Despite the killing, kidnapping and diseases brought by the Europeans, the Tarkiners persisted longer than most of Tasmania's clans. It was in this region that George Augustus Robinson made contact with the last of the free-living Tasmanian Aboriginals, and persuaded them to give up their land and be relocated to Flinders Island. By 1835 he felt he could write that 'the entire Aboriginal population are now removed', but in this he was quite wrong, for until 1844 a man and a woman, with their three sons and two adolescent males, still walked their country in Tasmania's north-west.

The European colonisation of the Tarkine has been fleeting and varied. Logging of the valuable Huon pine occurred along the Pieman River (the northern limit of its distribution) in the late nineteenth century, but that resource was quickly exhausted. Sheep were grazed in the Tarkine's north until the early 1830s, and cattle have been driven across its coastal plains. But in a striking parallel with the Aboriginal use of spongolite, it was minerals, mostly yielded by the region's ultramafic rocks, that drew men into the Tarkine's rainforests. Traces of gold were discovered in a tributary of the Savage River in 1879, sparking a short-lived rush, and in 1881 more gold was found at Corinna on the Pieman River. That river, incidentally, is said to take its name from a less savoury period in Tasmania's past, when the most irredeemable of convicts were sent to Sarah Island in Macquarie Harbour. The story goes that on one occasion several convicts made a desperate bid for freedom, among them a pie-maker, and when he was finally located by the authorities on the banks of the Pieman River he was alone, and carrying in a sack prime cuts taken from his fellow escapees.

Following the brief gold rushes, mineral exploration revealed that the region harboured economic deposits of tin, silver, osmiridium and magnetite, and after the prospecting era, some of the richest of the mineral deposits resulted in the establishment of mines. The earliest of the mining towns was Magnet, located in the headwaters of the Arthur River. Its inhabitants made a living digging for silver and lead, an enterprise that persisted until 1940 when the entire settlement was sold by auction and the forest slowly started to reclaim its own. Today, the only mine operating in the area is the Savage River magnetite mine, which pipes its ore as a slurry through a pipeline which traverses the Tarkine before emerging at Port Latta on Tasmania's north-west coast.

Taken as a whole, however, European impacts on the region have proved fleeting and, except for the devastating destruction of the Tasmanian Aboriginal cultures and the extermination of the thylacine, have had little lasting effect. The search for minerals has perhaps been the greatest economic bane of the region, not through any damage done on the ground but because the preservation of the Tarkine's natural assets has constantly been opposed by those who still hope for mineral riches. Yet in truth the wealth created by mining has proved to be transitory, and is declining. Meanwhile real wealth is being discovered elsewhere: a 1994 local government report on the region noted that 'Tourism and especially now eco-tourism is fast becoming the only growth industry on the west coast, with in excess of 120,000 visitors per year going through Queenstown–Strahan–Zeehan'.

One of the greatest tragedies of Tasmania is that its European inhabitants have always wanted their island home to be something it is not – a little England perhaps, or the world's largest sheep paddock or even, in later years, the Ruhr of the South (which

was to be powered by Tasmania's out-of-control hydro schemes). All such dreams have failed, but nevertheless their pursuit has cost the present generation dearly.

We can easily imagine a different history for Tasmania. One that began with Governor Arthur setting aside the western half of the island for its Indigenous inhabitants, thus creating the basis for good relations between black and white and permitting a flourishing Tasmanian Aboriginal culture to persist to the present day. Free from persecution, the thylacine would also have prospered in the Tarkine (where, indeed, some of the last sightings of the creature were made) and the astonishing natural beauty of Lake Pedder would have remained untouched. In this other Tasmania, some enlightened premier would have realised the value of the asset represented by Tasmania's west. Perhaps he or she would have travelled to Harvard University in the company of the great Tasmanian biologist Professor TT Flynn (father of actor Errol) and convinced the board of trustees to establish a Tasmanian field station for the university, so that Harvard's staff and students could engage with Tasmania's unique natural history and human cultures. Enchanted by the beauty of the isle, many Harvard alumni would doubtless have been tempted to establish themselves there, some to retire and others to set up businesses — and of course Tasmania's best and brightest would have had direct access to a Harvard education. In this alternative Tasmania, black and white forged lasting bonds of friendship and mutual cooperation, together managing a natural heritage that was the envy of the world. And, by virtue of their direct link with the richest and most influential people in the Western World the Tasmanians had become comfortable leaders in their country, with a high-tech industrial base that trod lightly on the land, yet which yielded considerable wealth.

This history, of course, is nothing but a daydream. The thylacine and Tasmania's Aboriginals were victims of real Tasmanian history, as was the most beautiful lake in the world. Yet the wonder of Tasmania's west, with its Gondwanan history and astonishing beauty and complexity, is still there, as is the opportunity to reach out to the greater world and so create a culture that would make Tasmania the envy of the world. But in order for that to happen, Tasmanians have to truly understand where they live and what their island's enduring assets are. Moreover they must preserve all that remains of those assets, none of which is more important nor more directly threatened today than the Tarkine. Its preservation and proper utilisation could open the way to a far better future Tasmania.

TIM FLANNERY

Photographing the land

Our world is filled with many things, some that are of our making, and others that are remarkably different such as mountains, clouds, rivers, trees, the sky and the sea. The minutiae and the majestic have equally stirred our souls, inspiring wonder, allegiance, curiosity and delight. Countless memories are defined by these moments, and our overall notion of them has contributed to an idea that we call nature. The history of landscape art traces our growing conception of nature and our relationship with it. Art, and creativity in general, extends our reality into the virtual recesses of consciousness, and the dreams and desires that flow from it. As artists, we reinvent these experiences, sharing our revelations, beliefs, hopes, passions and ignorance.

For centuries, lens-based technology was used to extend our vision and understanding; to see further and deeper than with our eyes alone. With microscopes and telescopes, and eventually with photography itself, we sought to explore and understand the underlying structure of matter and the depths and mysteries of the universe. This quest was based on a belief in nature's continuousness, which made perfect sense when seen through our eyes, on our small planet, and in our own backyard. Photography's inherent ability to reproduce continuous tonality did nothing to dissuade us from this assumption. Up until quite recently, and in some disciplines not until late in the twentieth century, we took for granted the boundlessness of nature. Our grand rationalist project was to capture the nature of nature as seen.

Since its invention in the early nineteenth century, photography has accompanied countless expeditions into distant lands. At first, photography was employed as a method of documentation, reporting found or assumed relationships with the land, thereby establishing the first tradition of landscape photography. These often exceptional documentary photographs had begun to evolve by the end of that century into pictorial images preconceived from an idea of what the land might also represent, be it poetic, mythological or spiritual. Mixed with a desire to proclaim photography an art form in its own right, the landscape became increasingly interpreted rather than documented, often echoing earlier traditions of classic landscape art.

Modernist photography, by the mid-twentieth century, had become associated with an overriding attention to the inherent qualities of its optical and chemical processes. Smooth-surfaced and silver-rich papers, extended depth of focus, heightened resolution and exquisite tonal renderings came to signify more than the landscape itself. Both informed and informative, these images often bridged the documentary and pictorial traditions, and inspired a post-war generation to consider even more personal or pressing visions. Landscape photographers began privileging a cooperative, or at least a humbled, relationship with the land, in the face of a growing ecological realisation that nature was, in fact, neither 'boundless' nor inexhaustible.

By the 1970s, during a time of growing social debate, increasingly urgent political and cultural realities dominated all areas of photographic practice. Photography became a site of intervention, redefinition and negotiation as it served the cultural, social and political issues of the era. With its formal inclusion in art school curricula and public art collections, the question was no longer whether or not photography was an art, but rather what was photography. While the photograph may have been innocently taken, that is, created innocent of the codes and conventions constructing its meaning, its reading remained buried in our interrogation of the world. The photograph as read, rather than as seen, had begun to dominate our cultural consciousness.

Landscape photographers reflected on and questioned ideas about rights, ownership and access; heritage, gender and race; perception, subjectivity and representation. Collaborative and community based projects flourished as the focus of art diversified through competing values and priorities. A new formalism emerged as the heroics of the past gave way to collective practices that privileged a respectful and cooperative relationship with the land. What was once the subject matter of landscape photography had become 'subject that matters' for landscape photographers.

Through the very design and force of the medium itself, landscape photography was embedded within nature. This is a significantly different practice compared with travelling overland for inspiration or source material, before returning to create in a remote studio. Landscape photographers must work in nature. More than a spectator, their direct participation and sympathetic engagement defines a symbiotic relationship with the land. Their work represents both the experience of being there, and the act of recording that presence. The landscape has become their studio.

The uniqueness of Tasmania's landscape, and in particular the Tarkine region, presents unequalled opportunities and challenges for landscape photographers. If properly understood, their work has the potential to reshape our intellectual, social, personal and spiritual relationship to the world. While it engages us with a fascination and reverence for the earth, I trust it will also inspire the motivation needed to ensure its preservation.

Les Walkling

A Community of Artists

My first year in Australia was 1982; I was ten. Until then, I had lived in Papua New Guinea, a land blest with a stunning diversity of flora, fauna and eco-systems – but also no stranger to breathtaking environmental destruction and controversy. My youth and outsider status combined to prevent a thorough understanding of what was happening at the Franklin River in Tasmania's south-west (preliminary construction had begun on the Gordon-below-Franklin dam and hydroelectricity plant). I do have vivid memories of the distinctive yellow triangular car stickers urging 'No Dams'. But it wasn't until I saw the images – photographs and television footage – that I could envisage what this river represented, and appreciate the impact of what was planned. Being a child, I was captivated more by the beauty and size of the river than by economic, environmental and political issues. The most famous image would be Peter Dombrovskis' photograph of Rock Island Bend, which appeared in full-page newspaper advertisements and on posters; my introduction to wilderness photography. Twenty-one years later, Robert Purves – in love with the Tasmanian landscape and shocked by the planned logging of rainforest from the heart of one of the world's great but little-known wild places – entrusted me with his dream: a book of photographs of Tasmania's Tarkine.

My initial steps towards the book were unwarrantedly tentative. The predictions of more experienced friends that I would enter a hornets' nest of squabbling artists came to nothing. Phone call after phone call to Tasmania's best wilderness photographers led to eagerly accepted invitations for a chat about the book and phone numbers of other potential contributors. Thereafter followed trips to homes and cafes in Ferntree, North Hobart, Salamanca, West Hobart, Newtown, South Hobart and Mount Nelson as I slowly acquainted myself with Liz Dombrovskis, Chris Bell, Ted Mead, Rob Blakers, Simon East, Geoff Murray, Loïc le Guilly, David Stephenson, and Greater Hobart. My meetings were fascinating and exciting; there was a sense of urgency. I was also being entrusted with an oral history of Tasmanian landscape photography and its intense relationship with the conservation movement. These were artists deeply committed to their environment. Although it is tempting to define some as artists first and naturalists second, or vice-versa, in reality the distinction is very much blurred. And it doesn't matter: they are all custodians of a tradition that demands their art, time and effort to preserve what they love. I came away inspired and humbled. More photographers were to come.

The Tarkine rainforests have a Lord of the Rings quality: emeralds and browns, filtered light, hanging moss, grand old trees, pristine waterways. But the Tarkine is more than that: its western boundary is a dramatic coastline with seas and winds rolling in from the Southern Ocean; its forested mountain ranges extend to the horizon in receding, overlapping fingers laced with mist and low cloud; its rivers have coursed deep into the topography. My immediate task was to see how many photographs existed that captured this spirit. A secondary aim was to gauge enthusiasm for collecting more images. Although there were light-boxes-full of outstanding images, many had been published, and we wanted a fresh crop. The response was overwhelmingly positive and generous: from Rob Blakers' 'What? We get to contribute to a wilderness photography book and someone else is going to do all the work…' to Geoffrey Lea's 'Great! I've been meaning to get into the Tarkine for years but something always gets in the way.'

As I was driving back to Sandy Bay from Ferntree after yet another chat, this time with Chris Bell, the idea came to me that we should invite as many photographers as were interested to come into the Tarkine for two weeks to take photographs. It was, as I discovered, unusual because photographers – particularly wilderness photographers – like to work alone. The kilometres walking off-track through dense rainforest or sodden waist-high button grass scoping for a perfect spot, the time to set up tripod and camera, the countless hours waiting for the light to be just right: none lends itself to working in a group.

The preliminary reactions to my suggestion were mixed and hardly ecstatic. Ted Mead was dubious: 'Ahhh, you'll be lucky to get the right weather at that time of year.' Kip Nunn was upfront: 'I prefer to be by myself when I'm out shooting the bush.' Alan Moyle was cautionary: 'Sounds good, but will everyone be able to come at the same time?' A perfectionist trait was shining through. They knew that the quality of the photographs, the quality of the writing, the quality of the whole book, could be nothing less than superb; it had to reflect the value of the Tarkine measured by their aesthetics and their conservation ethics. Undeterred, and driven by the need to find over one hundred varied and publishable images in less than eight months, I set out to recruit for what became the 'Fortnight in the Tarkine' or just the 'Fortnight'. We wanted to inspire writers too, so the invitation was extended to a long list of prose writers and poets, a good number of whom accepted. We were joined at various stages by a team from Outdoor Magazine and documentary filmmakers David

Warth, Joe Shemesh and Troy Melville. Like the photographers, these filmmakers are astoundingly committed to their art and the environment: David wandered the Tarkine for nine months – mostly alone – filming for his thirty-minute ABC TV documentary Tarkine: A Forgotten Wilderness, and Joe has spent many patient weeks alone with heavy equipment to capture the perfect footage in perfect conditions.

Early on, I was struck by the age gap between the older generation (among them Chris Bell, Ted Mead, Rob Blakers, Geoff Murray, Geoffrey Lea, Grant Dixon and Rob Gray) and the next group of wilderness photographers (including Dave James, Simon Olding, Al Dermer, Glen Turvey, Andy Townsend, Mike Thomas and Alister Mackinnon); I had expected a continuum of ages. I was also surprised by the almost exclusive grip that men hold on the genre, at least in the public arena: Anah Creet and Shoshana Jordan are the exceptions here. Part of my idea had been to use the Fortnight as a way of mentoring the younger generation. This proved difficult to organise, and I left it. However, exchanges during the Fortnight – about the relationship between photography and truth, the comparative merits of large-format cameras and 35mm SLRs, the place of people in landscape photography, the validity of 'rules' like never shoot into the sun – indicate that the younger and older generations learnt from each other and themselves in any case.

Among the photographers, there was clearly a tension between pursuing perfection in a known art form that has been expressed for over a century and exploring new possibilities of the photographic medium, each with its own challenges. But everyone was aware of their place in a long tradition stretching back to the early European and North American landscape photographers, and beyond that to the pioneers of photography itself. A few had been contemporaries and friends of the most celebrated of all Tasmanian photographers, Peter Dombrovskis, and everyone knew of him and his mentor, Olegas Truchanas. Some of the photographers saw this trip as analogous to Olegas' trips to Lake Pedder in the 1950s, 60s and 70s and Peter's trip down the Franklin River in 1979 when he brought back the famous and era-changing photo of Rock Island Bend. They were bringing a remote and special area to the living rooms of people who could not experience it first-hand. They were playing the role of storyteller. Equally as importantly, they have a role of documentary-maker, of historian, recording a place for future generations in case it is degraded or destroyed by logging or other extractive industry.

The writers were as diverse as the photographers, although, in this case, were mainly women. Some seemed as fascinated by the language, science and tradition of photography as they were by the Tarkine itself, but their commitment to the environment was obvious. Their representations complement the photographs, bringing a different light to the Tarkine, their art able to describe and explain different ideas, emotions and histories.

Jarrah Keenan, Rob Fairlie, Christoph Farrell and Darvis at Tiger Trails helped put together the itinerary for the Fortnight. They know and love the area, having spent months living in the rainforest. During 1995 and 1996, Jarrah worked with others – ultimately without success – to prevent the building of a white gravel road south–north through the middle of the Tarkine. The road is known to the government and development protagonists as the 'Western Explorer' tourist route but was dubbed the 'Road to Nowhere' by environmentalists because of suspicions that it was simply a way of splitting the Tarkine in two and opening access for logging.

I struggled to mediate Tiger Trails' enthusiastic desire to show off as much of the Tarkine's diversity with my more pragmatic concern of having enough time in one location for photographers and writers to feel a connection with the place and get their shots, especially with unpredictable weather. We arrived at a plan that took in the rainforest around Savage River and the Natural Arch, the coastal sweeps and rivers near Pieman Heads, and the ranges of Mount Donaldson and Mount Ramsay. Once underway, we added two days among the plains and tall forests along the 'Road to Nowhere'.

Early in the Fortnight, Jarrah stopped us in open rainforest on a spur between the Savage River and the Longback, paused, and said quietly and with an unassuming shrug, 'I brought you here just because I like it and I knew you would too.'

For the next two weeks, a community of thirty-five artists expressed their vision of our Tarkine through their photographs and their writing. If we are to appreciate what is truly valuable in our world, the repercussions of their work must extend beyond these artists, beyond these two weeks, beyond this book and, ultimately beyond the Tarkine.

RALPH ASHTON

The Tarkine rations nothing. It gives its all in a fury of excess that is raw coast, mountain ranges, dark gashes of gullies and the benediction of unbroken tracts of old-man rainforest.

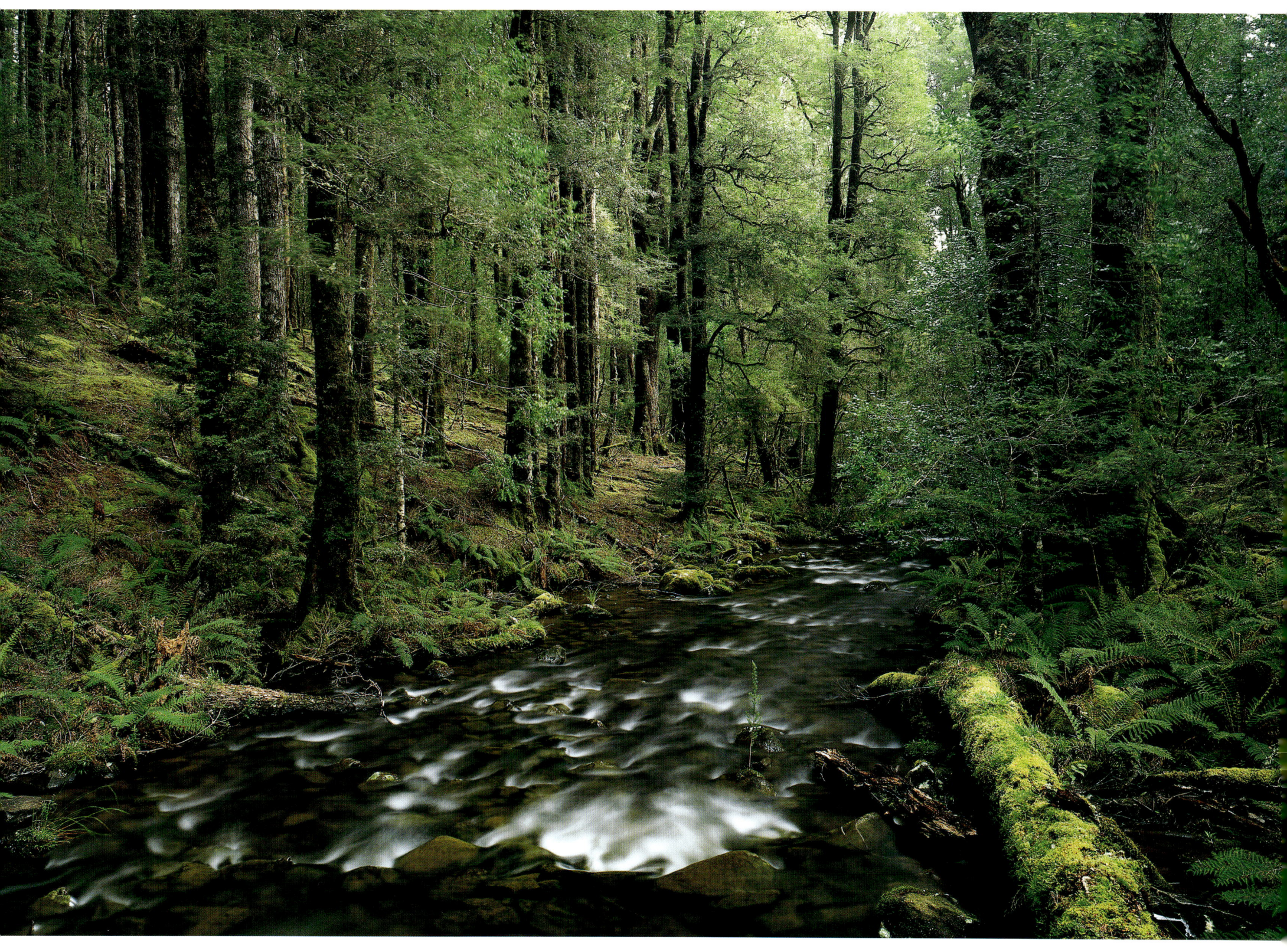

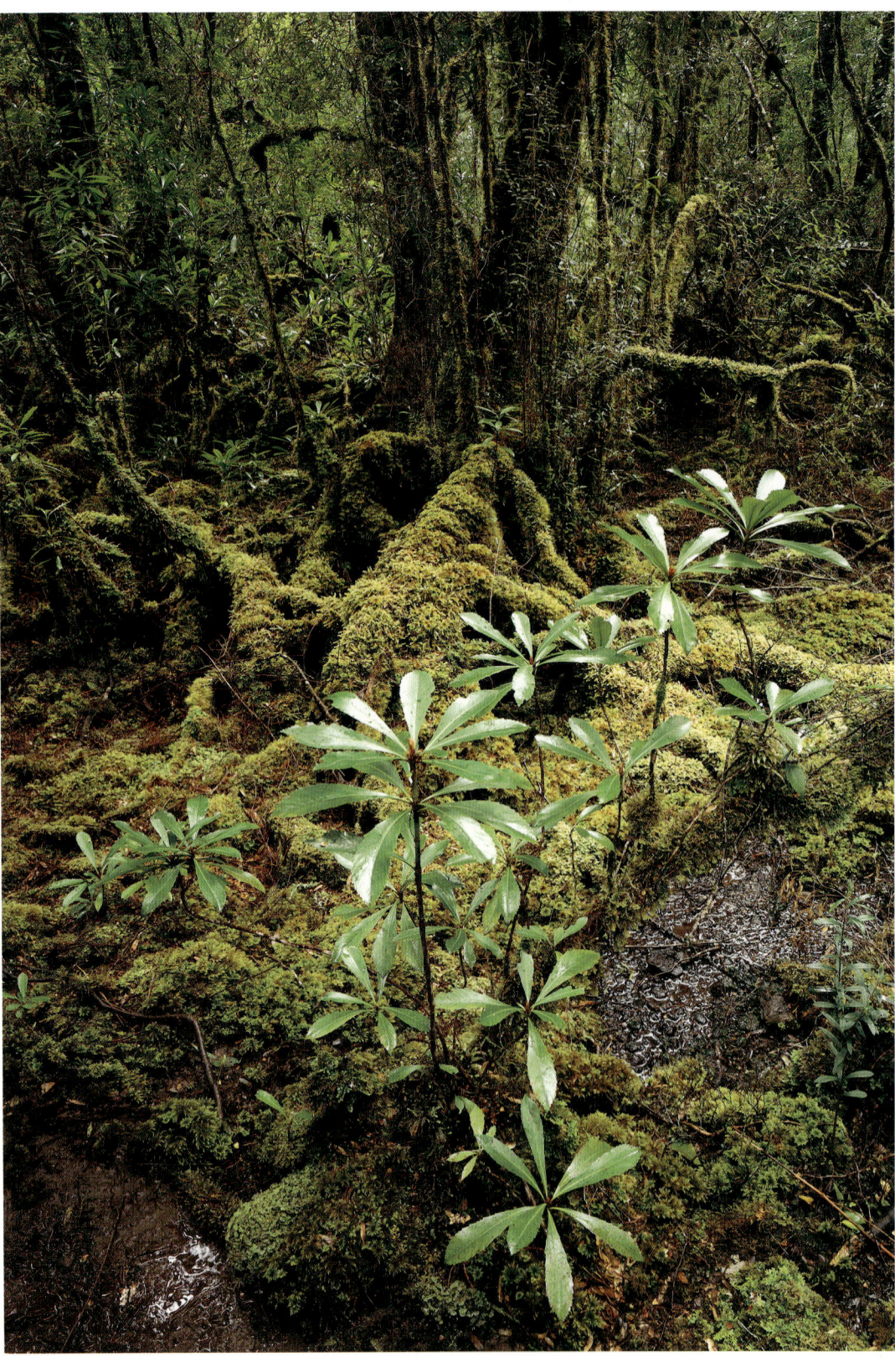

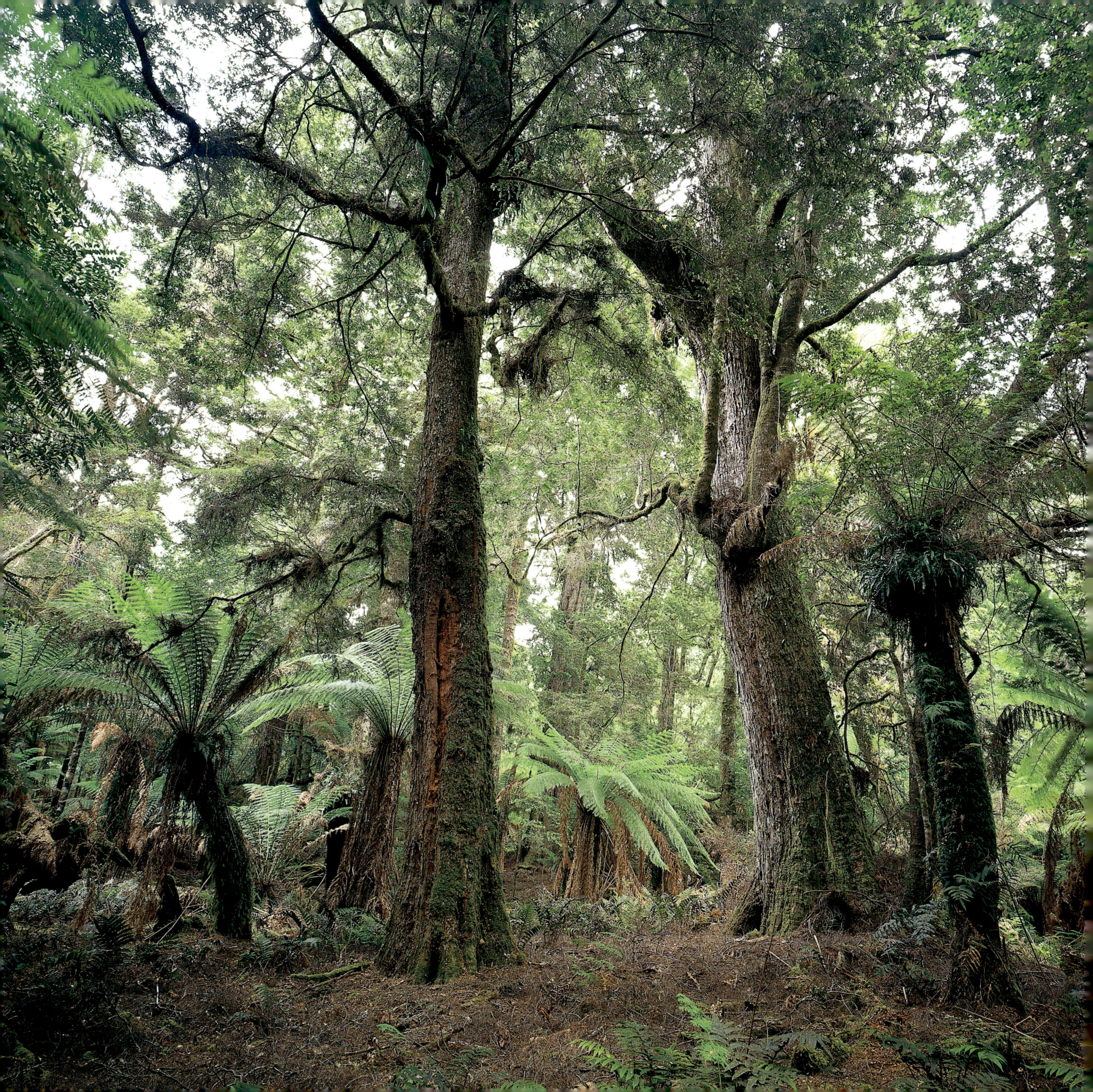

Like a reflection of our former lives,
we are stalled fountains of green.

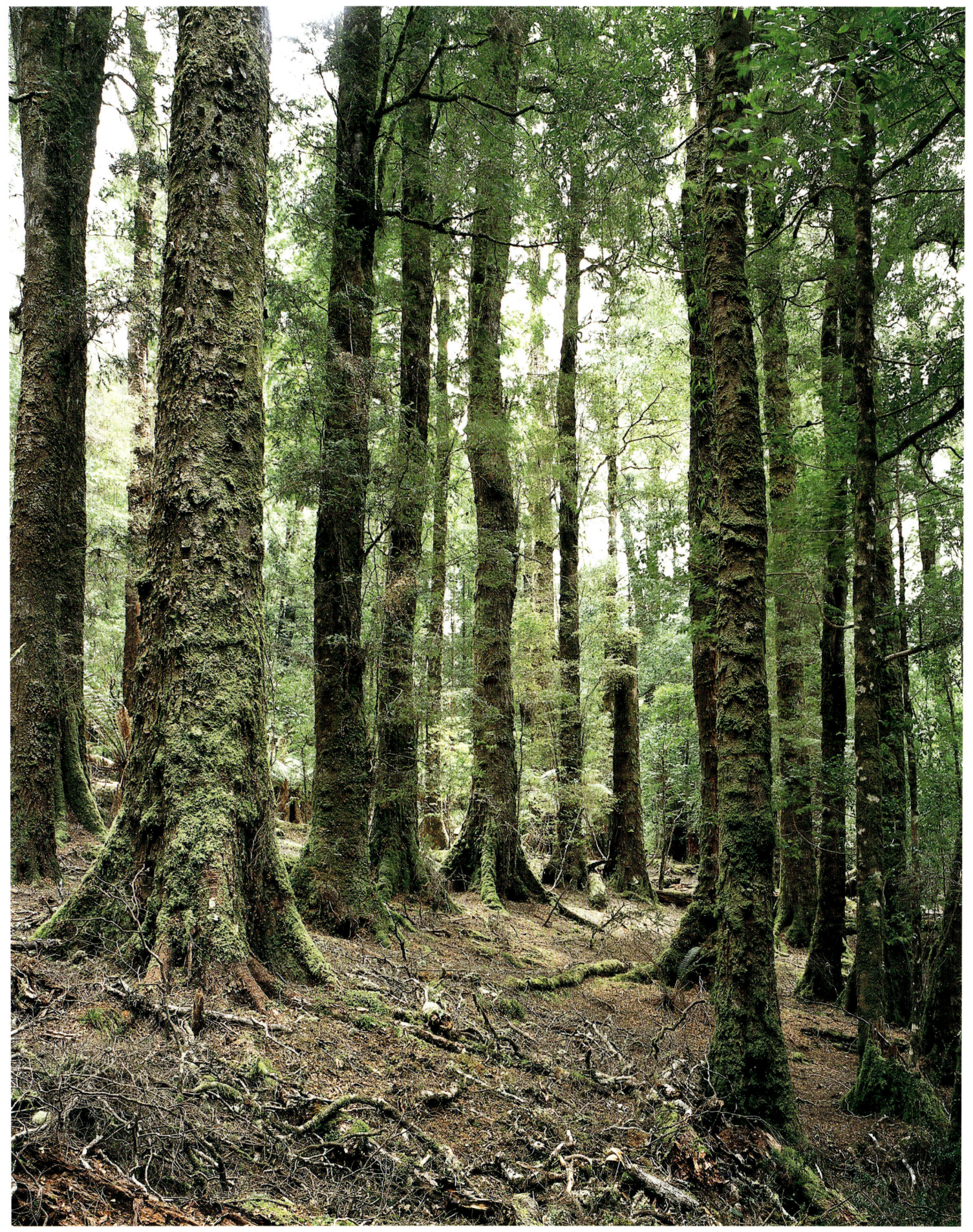

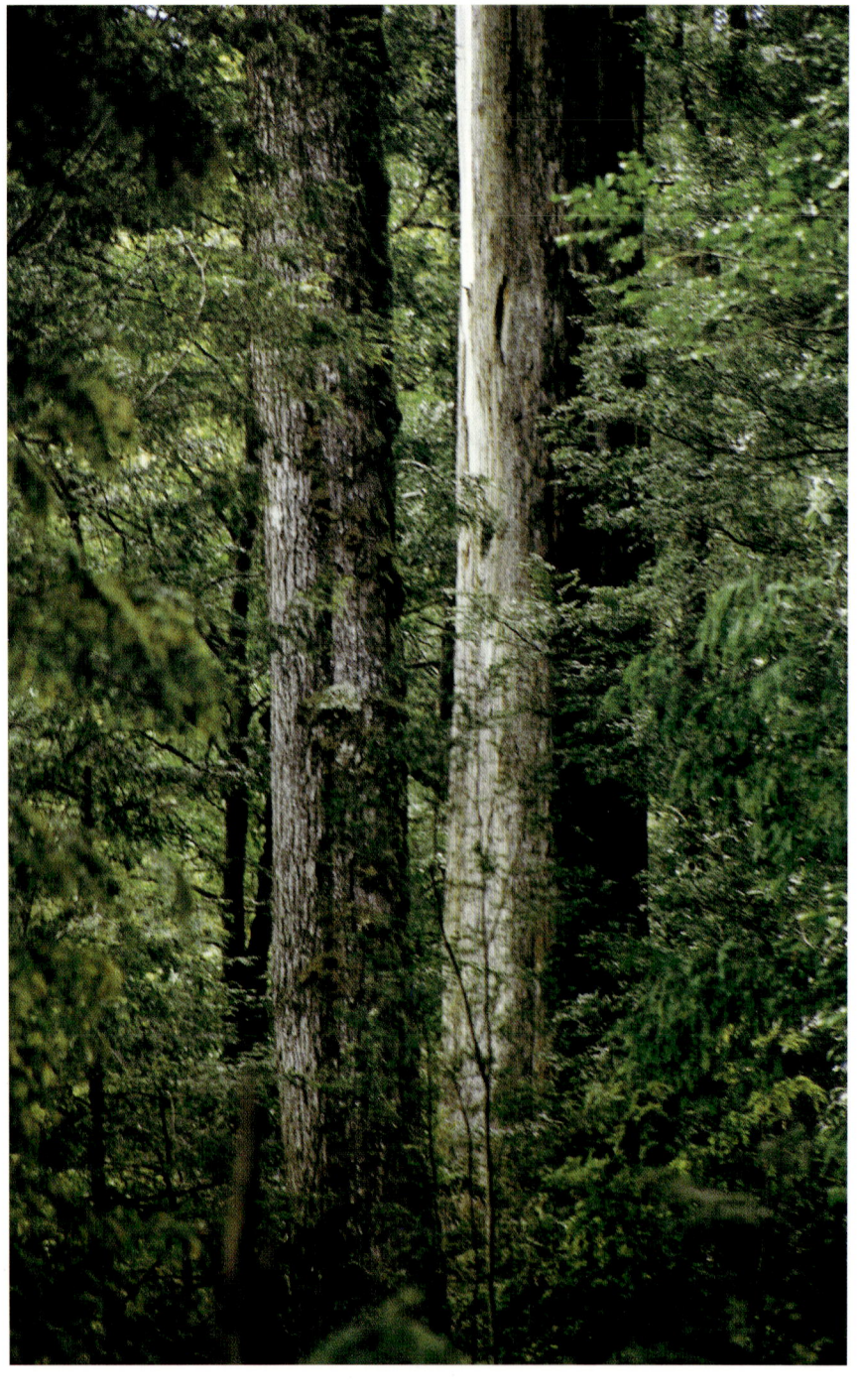

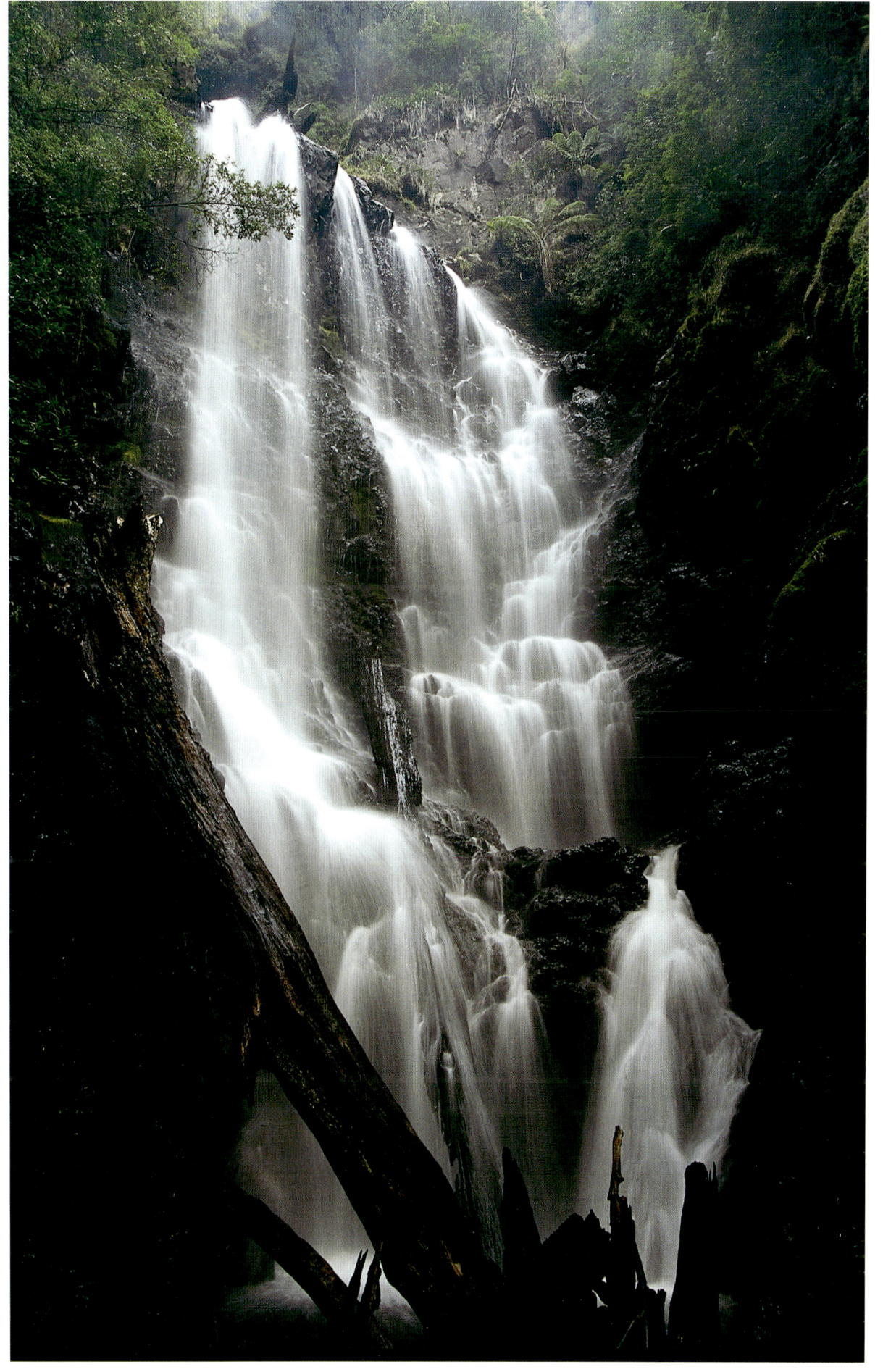

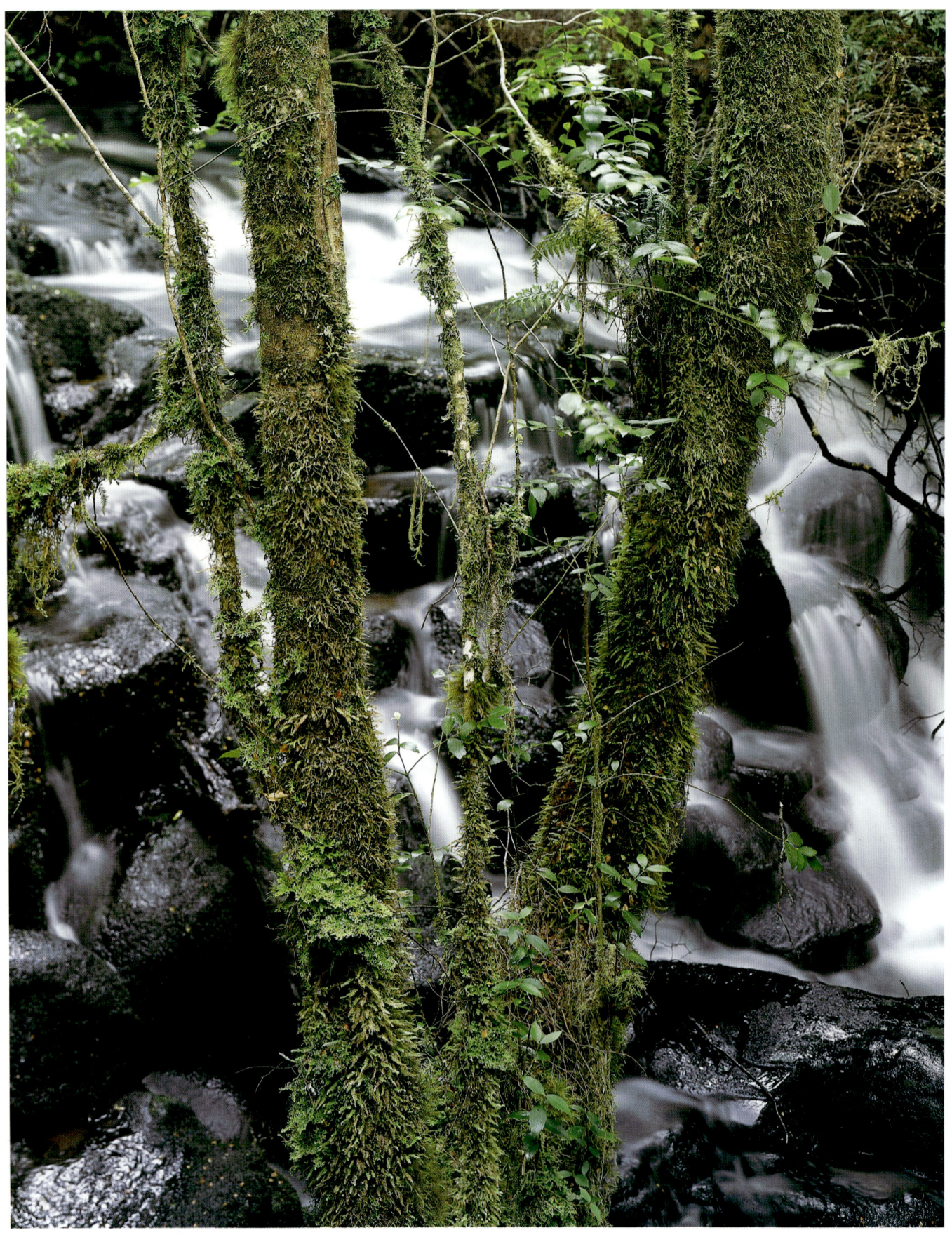

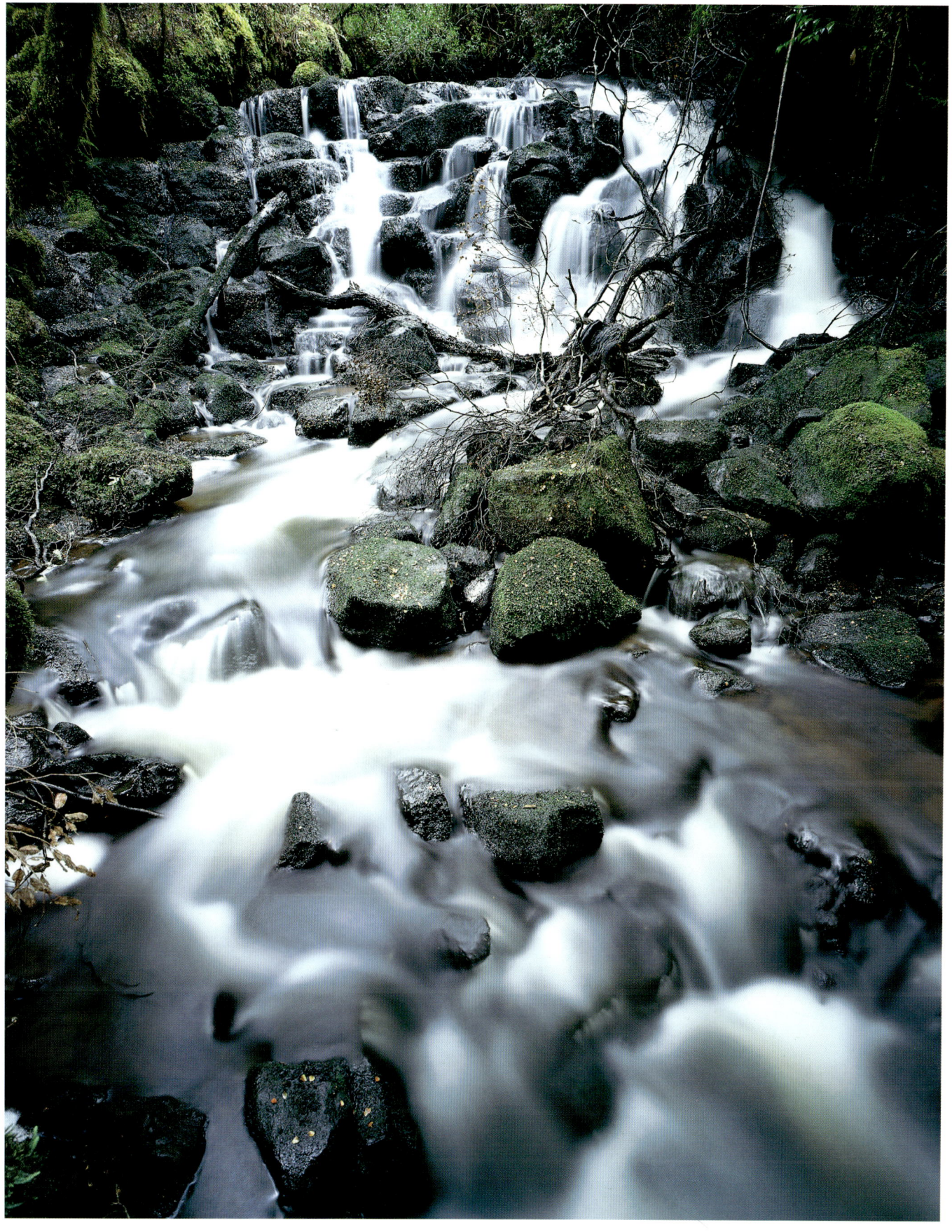

Where is the thylacine, that his voice might be heard, or the communities of Tasmanian Aboriginals that their understanding might be sought? Too long have we played the role of conqueror and not of steward.

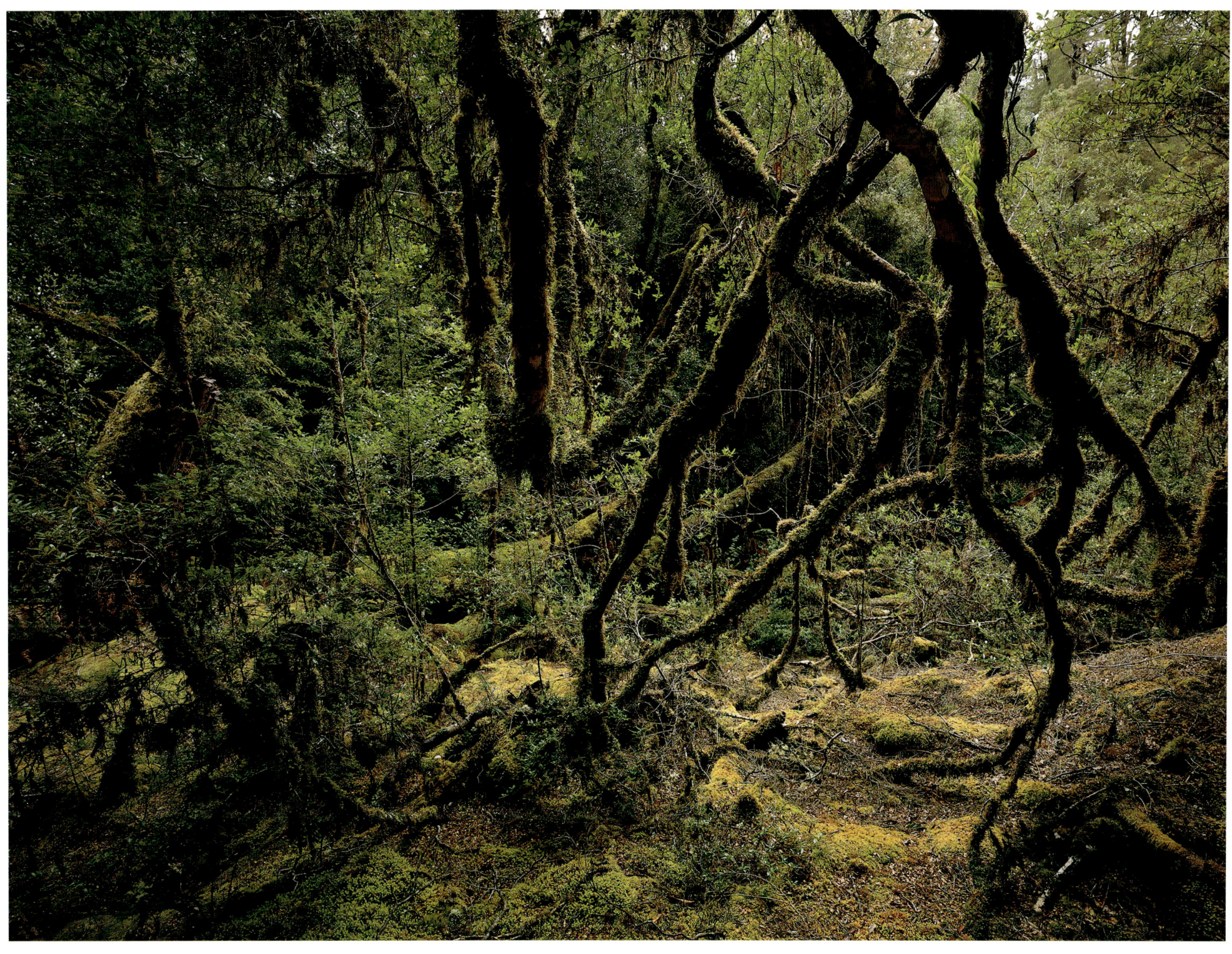

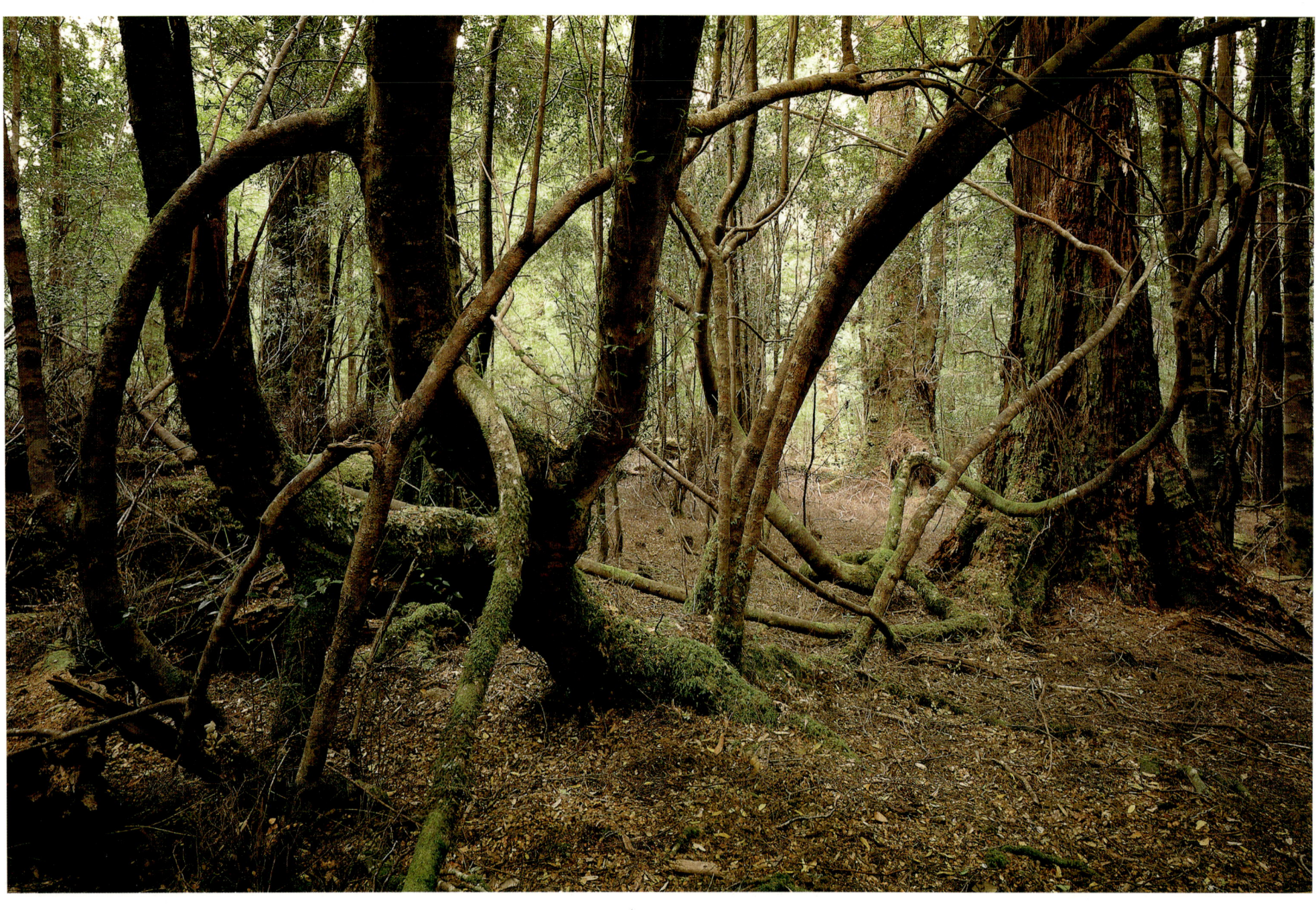

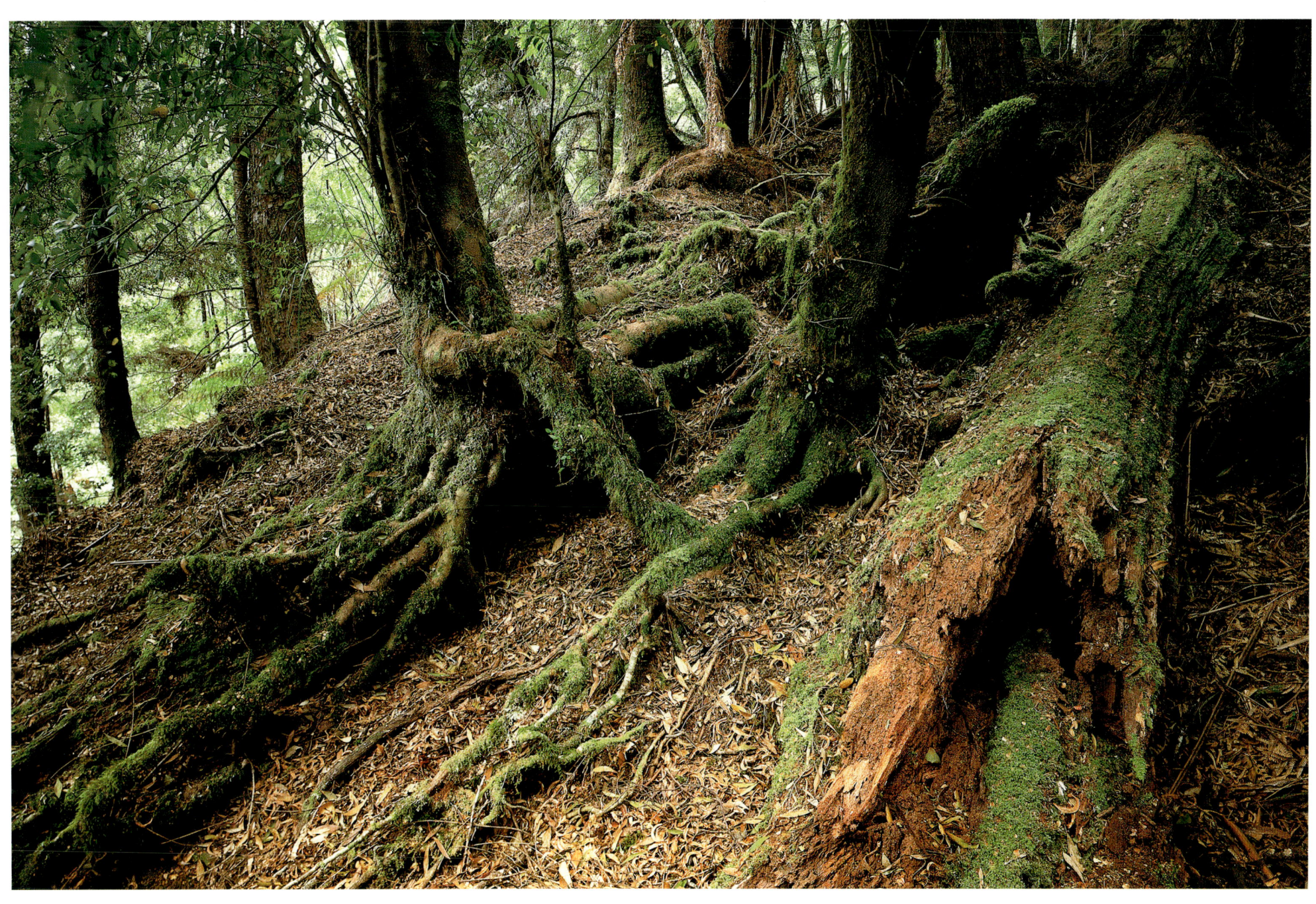

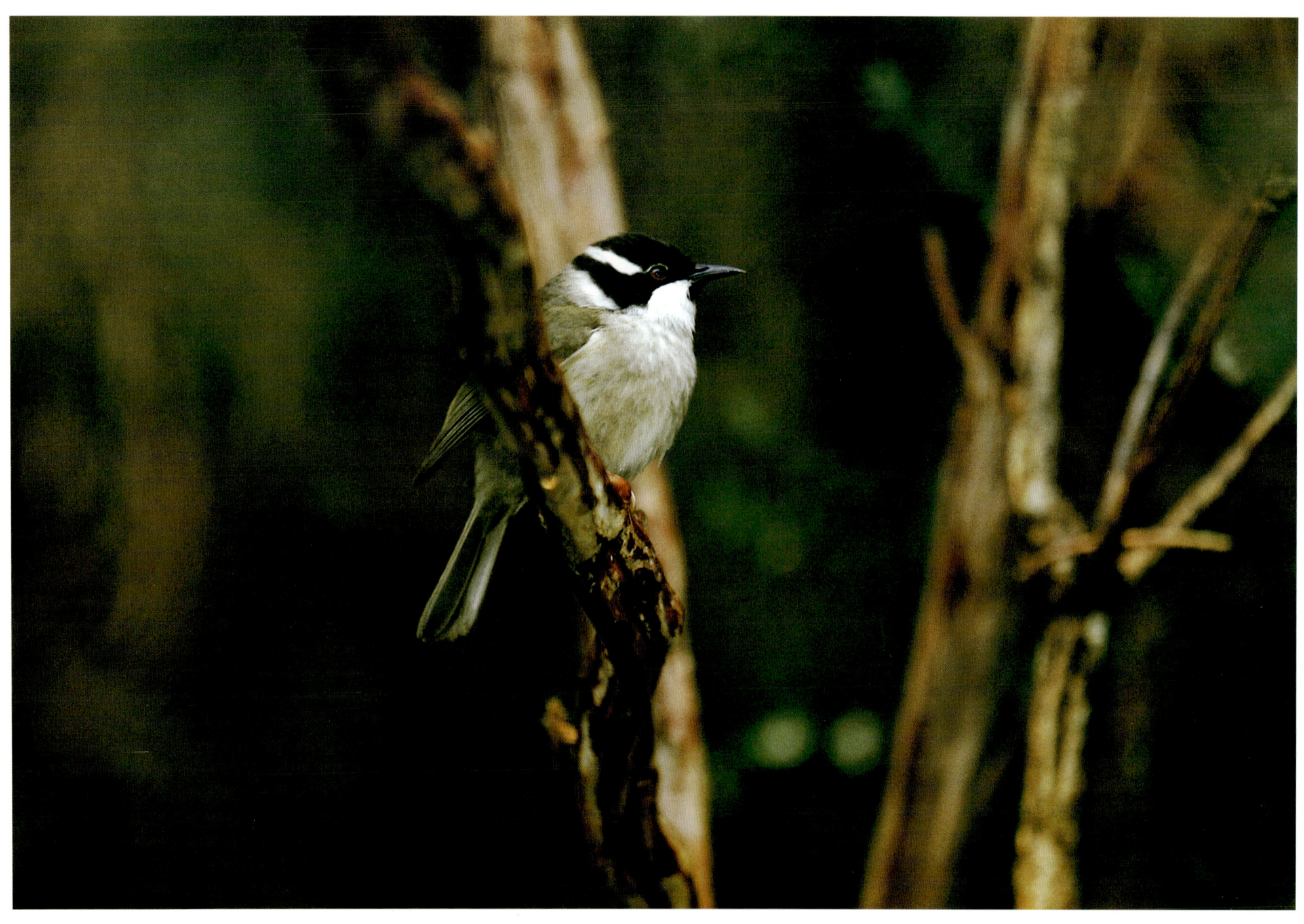

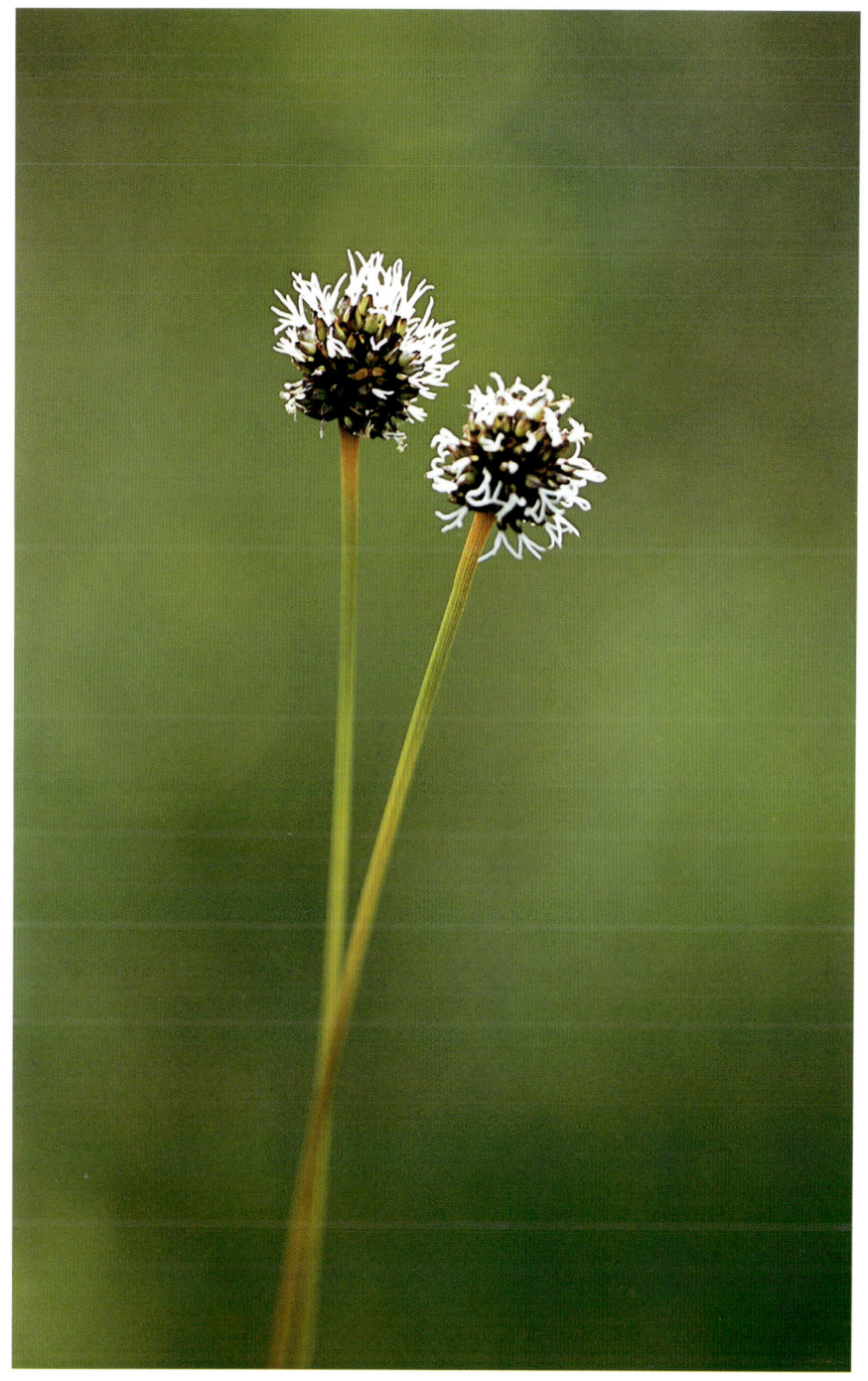

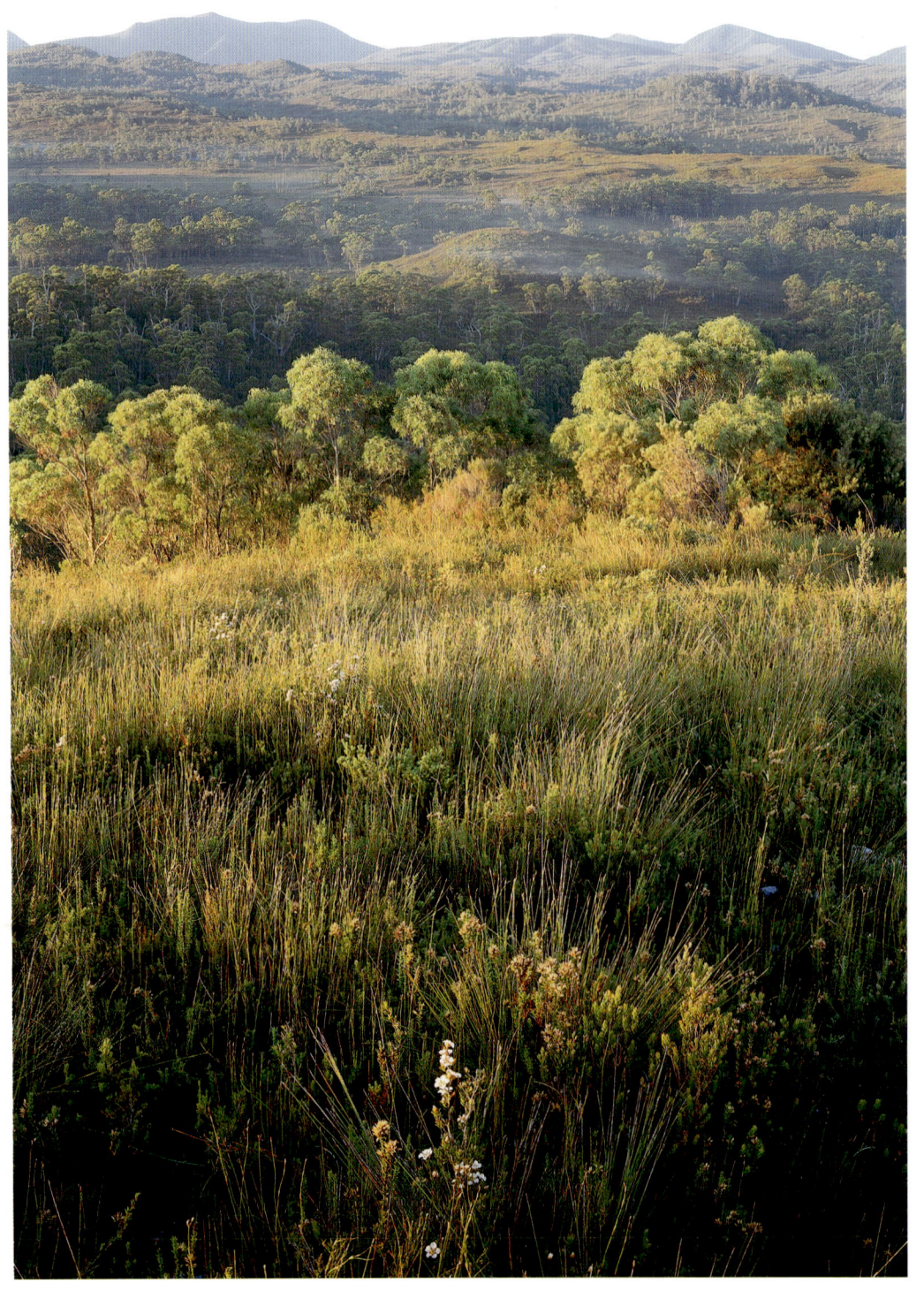

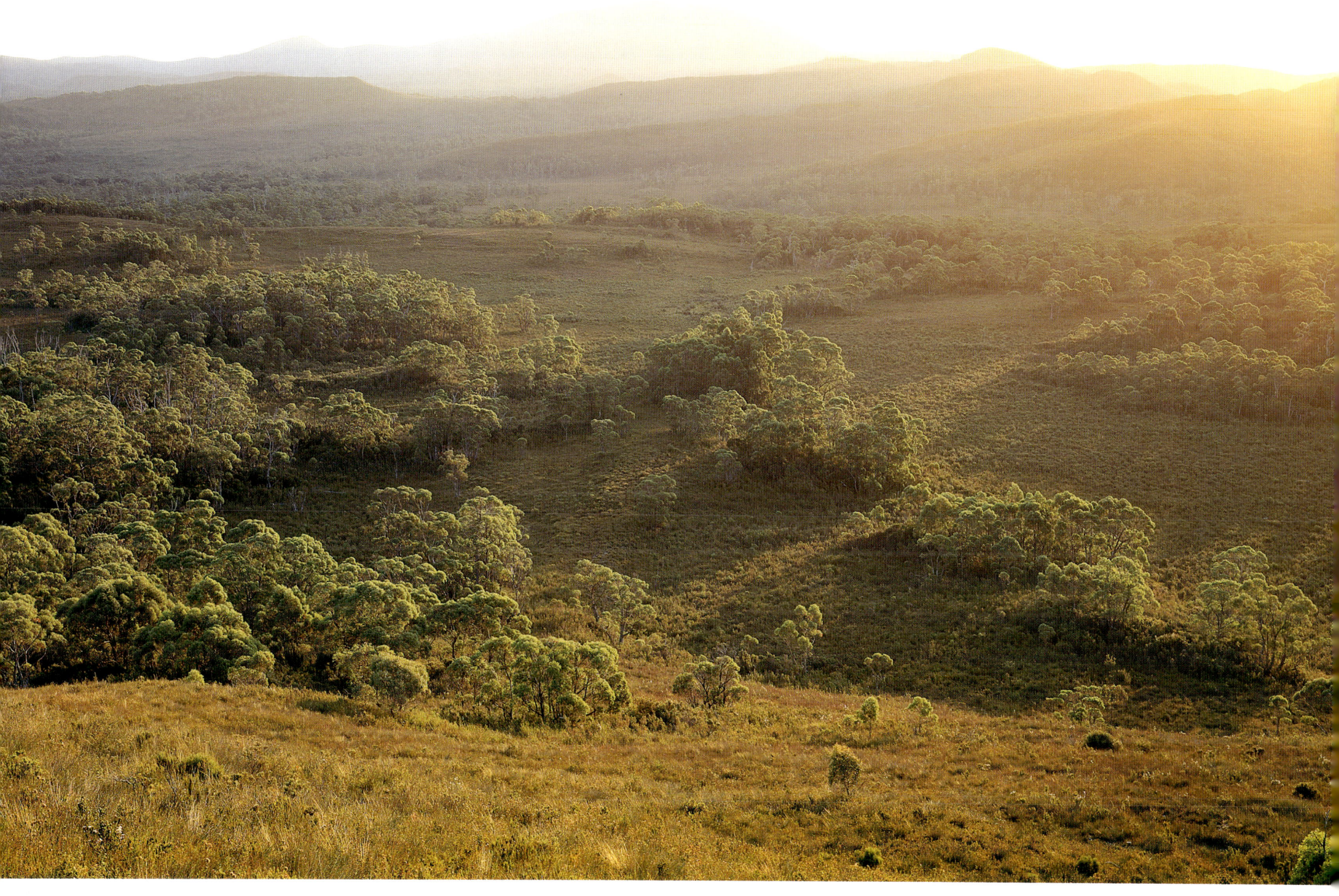

You can gaze at the view as you do a fire, quite happily and without boredom.

Oh that the fast-world pace would step into *this* place.

Meanwhile we wear the earth,
slick as a lichened log or as a stone
that's worn by speedy water slowly, slowly.
Quick as a skink will scurry we are sped
by navigating through the Horizontal,
to pre-mammalian time, confounded by the loss
of distance and direction along with sun.
Moving slowly, stopping often, reaching
timelessness takes just no time at all.

A great many trees stand here.

Did we then put them there, that they are ours to take away? Did we plant, tend, or care for them, that they might be ours to uproot? By what right then, do we take that which is not ours; were they given to us, that we might do with them as we wish?

43

the sound of the sea, a sound more constant than the sound of breathing

The Arthur | In late spring we walked into the Arthur north of Mount Bischoff, where it's young and fast, a wild pup of a stream, a tangle of currents and eddies, on its surface fallen leatherwood flowers being swept furiously along, and even then, in its narrowness and youth being so very, very black.

 This was the first time we'd visited the river at this point. The darkness of water was so profound we stood there a long while staring into it. There appeared to be no layers of depth. No shifts of light or translucence or wayward fluidity you'd expect from a river not long out from its birthplace. The Arthur, on the rough old Magnet mine track, seemed to have dispensed with such childhood prettiness.

 Oh, and it was fast. And even though we could easily throw stones from where we stood on one side into the bush on the other side, we felt—maybe irrationally—that even if we were to attempt to cross the river we'd get swept furiously away like the leatherwood blossoms.

 That's the thing about the rivers in the wild parts of Tasmania. They don't know when to stay quiet.

If the thylacine continues to exist, the Tarkine is its home.

Trees have bones, you said
and the air changed.
Mosquitoes shifted from the space
between my hands,
soldier ants spread out
from the shadow of my foot.
Tree bones, you said
and I held my breath.

The orderly restlessness of turbulence and motion, captured in the sound and sight of Southern Ocean waves.

Below, a burst of bright green sound bounces downhill, compelling reaction
from kindred chords. Not one can be spied within the sculpted tuck of heath.
Above, in the evening gold, there is the flash and dip of three, no four,
spring rocket parrots, with fire in their bellies and seedy eyes.
Their journey south, now maybe too late for a new batch, holds no want
for surprise, tracking the flickering hazards in the free fly space.

TARKINE

WWF

OWN A PIECE OF THE TARKINE

All the photographs in *Tarkine* are available for individual purchase. They will be professionally printed on archive-quality photographic paper. They can be purchased framed (museum grade) or unframed.

For sizes, prices and delivery costs, please:
visit www.wwf.org.au
phone 1800 032 551 (in Australia)

Any profit from sales of photographs will be shared between the photographer and WWF Australia.

WWF is the world's largest independent conservation organisation. It has 5 million regular supporters and a global network active in more than 100 countries.

WWF Australia manages more than 180 projects across Australia and Oceania, working to protect, manage and restore the region's land, fresh water and marine resources. WWF Australia aims to raise awareness of the key environmental challenges facing the region and engage Australians in developing solutions. One of WWF Australia's current focuses is forestry management in Tasmania. As part of that focus, WWF Australia seeks protection for the Tarkine through the prevention of logging of the Tarkine's forests.

For more information about WWF Australia's work, or to make a donation, phone 1800 032 551 or visit www.wwf.org.au

Overleaf: © Ted Mead, November 2003. Moss-clad Sassafras (*Atherosperma moschatum*) trees in mist in the Arthur River catchment near Waratah, Tarkine, Tasmania.

The overwhelming memory is that the land was not empty. The wind, the rocks, the sand all sing of its lost people.

81

Go down by the water
to the edge of the moment
and turn on again
Down by the water
where my memory stands
it's heart stark naked
held in time, caught in this land
I cry free, I am
We cry free this land

85

being in this Forest
Recreation
say it differently
and it makes more sense
Re Creation
reinventing my soul

The Savage | There are times after long rain when whole forests on either side of some Tarkine rivers become so submerged in turbulent water you wouldn't know they were there.

We knew about them, because we'd found out from the times we'd been in walking, that no two trips to the Savage where it flows below Mount Donaldson were ever the same. One time we could arrive at the river and the ford would be above water.

When it was we'd cross, albeit carefully for you never took the Savage for granted. Once when we took the beagle in he slipped into the water and the current caught him. Dogs don't let themselves get concerned about such things. He merely let himself be swept along until he got caught on a branch then hauled himself out.

We clambered through the button grass up the mountain that day. From the top we saw the Pieman and rivers flowing into it. When we came to cross the ford on the way home the river had already changed. Somewhere upstream the spring snows must have been melting for the ford was only just visible in parts and we had to stiffen our resolve and run quickly across, our hearts pounding, water lapping at our ankles and the memory of the beagle being carried away on our minds.

That was when the Savage was in a benign mood.

Another time and the river would be moving like some giant fluid behemoth across everything in its path, covering the bush for miles and miles around.

At those times the track just vanished straight into the water as if it had hit a brick wall. Sometimes even the trailing wires of the unsteady flying fox upstream from the ford were beneath the flow.

The first time we saw the Savage in flood it took our breath away. It wasn't because the river was dashing at break-neck speed and sending up white foam, but because it was so vast. It was as though the river had run away with itself and grown bigger and bigger and bigger.

Yet in its vastness and in its inexorable slow moving and even though it carried the detritus that goes with human intervention, it was possessed of a grand and powerful loveliness.

Breath seems suspended in this place.

No middleman here, just a covenant between what was and what is.

centuries-old logs stand sentry-still

A couple of lines to describe,
at least a billion years to unfold.

There's more, but I'm blinded by ignorance, and have to be content to see without naming.

There's movement
between birds and trees and air
a quivering of the earth
on which she sits sharing
leaf futures with minute creatures.
Through branches she looks
up and up to tips of ancient trees
high as church steeples
more precious than old gods
who were just as vulnerable
to politics and greed.
She will lie there when they come
listening for eagle wing beats,
seeing every shade of green and myrtle red,
every vein of life around her,
smelling deep soil as she rests her head.

Whatever our plans, the land is not static and continues to evolve.

With eyes wide open, the myriad of living things appears beyond the simple definition of a forest having trees.

sit softly.
watch softly.
enjoy the smell of green.
stream measures
the passage of time
a watch that
doesn't inspire activity.

The river talks in time and green.
Split sky. Rock iron. Tideline. Lifeline.
Waterland. The inbetween.

Understorey speaks a seam.
Silver, copper, rush of gold.
The river talks in time and green.

The long way home turns a corner down
a gravel road where the view opens out
like a favourite book: sea binds one edge,
hills roll back the other. In between
the pages of gums, lightning forks upside-down
tipped with green, three gullies of ferns
lead the eye to a myrtle tree
standing alone, the strongest stanza.
Shafts of sun lie balanced on its branches
which sieve so finely light barely dusts
the ground. Twice I've pushed my way
under headdresses, through the parade,
to sit, my back against its trunks hard back.
A green skin on the south side planted
a damp kiss between my shoulder blades,
and filtered by the canopy subtle lines
hung in the air like those that connect
you to me and us to a passage in time.

The sky is never still; shadows stroke the underbelly of the claire-obscure clouds.

The island's photographers work not just for Tasmania but for a world in need of wildness. Even if we cannot physically go there to discover the secret at the heart of the Tarkine, we can still draw sustenance from the images that leap from the page, from the screen, full of unmediated life and longing.

The Fortnight

Forty-three photographers and writers contributed to this book. Between 25 October and 9 November 2003, thirty-five of them (accompanied by four guides from Tiger Trails) carried cameras, tripods, film, note pads, pencils, tents, sleeping bags, wet-weather clothing, gas stoves, food, a guitar and a sometimes-functioning satellite telephone into various parts of the Tarkine. They were joined at times by filmmakers and journalists. The rest explored the Tarkine in their own time, either later in 2003 and 2004 or in years past. They did so by car and minibus, on foot, by kayak and from helicopter.

 The main party began its journey with three nights camped in the rainforest beside the Savage River, with day walks through the Tarkine's infamous tangled 'horizontal' forest to the Natural Arch and through the open rainforest of the Longback. From there it moved north to spend two days on the plains and ranges along the 'Road to Nowhere', overnighting among the tall forests in a camp that had been used by environmental activists in 1995 and 1996 during their protest against the construction of this road. The rivers and coast came next: the photographers, writers, filmmakers and gear were ferried by dinghy from Corinna down to the Pieman Heads, setting up a base camp for four nights. The days were occupied with boat trips up the Pieman and Donaldson Rivers and day walks north along the coast and south to Conical Rocks. After another round of ferrying back to Corinna, the group decamped to pitch their tents for two nights just below the summit of Mount Donaldson, using the days to explore the nearby ranges. The Fortnight ended with five days and nights on and around Mount Ramsay.

 The weather was typical for spring in the north-west of Tasmania: short periods of rain were followed by lengthier periods of cloud-filled skies and brief bursts of sunshine. In addition to the traditional porridge and tea for breakfast, meals included Japanese nori rolls, Mexican stir-fries, pasta with Italian vegetable sauces and Middle Eastern flat breads.

139

The Tarkine Boundary and Reserve System

The term 'the Tarkine' is used broadly to describe an area of north-western Tasmania extending roughly from the Arthur River in the north to the environs of the Pieman River (including Conical Rocks) in the south, and from the Murchison Highway in the east to the Southern Ocean in the west. The photographs in this book were taken within this boundary and in some cases look into country beyond it. The Australian Heritage Council (a federal government body) delineates a specific boundary for the 'Tarkine Wilderness Area' listed on its Register of the National Estate (see map), and two proposals for a Tarkine National Park and World Heritage Area (1992 and 2004) use slightly different boundaries again, in all three cases for technical reasons.

In Tasmania, areas can be protected to varying degrees under a reserve system. The Tasmanian Parks and Wildlife Service (a state government authority) manages the majority of these parks and reserves, while Forestry Tasmania (a state government business enterprise) manages state forests and forest reserves. Logging is restricted to state forests and private land.

The Tarkine (as delineated on the Register of the National Estate) contains wholly or partly: one national park (Savage River), one state reserve (Pieman River), three conservation areas (Arthur–Pieman, Bernafai Ridge and Heazlewood Hill), one nature recreation area (Donaldson River), three regional reserves (Savage River, Meredith Range and Tikkawoppa Plateau) and five forest reserves (Sumac, Huskisson River, Arthur River, John Lynch and Hatfield). The remainder is state forest, Hydro Electric Corporation land, non-allocated Crown land or private land.

Although much of the Tarkine is covered by one kind of reserve or another, many of its unique, special or fragile characteristics are under threat. The Tarkine's large tracts of state forest – which include its most substantial areas of intact rainforest – are available for logging. Indeed, in June 2003, the Tasmanian government announced plans to log rainforest in the Savage River corridor (state forest to the west of the Savage River National Park and Savage River Regional Reserve). Further, the wide range of activities (including mining) permitted in most reserves (excluding national parks) leaves the real potential for steady erosion of the very natural and cultural values these reserves are intended to protect. This is exacerbated by the relative lack of management resources compared with the size of the reserve estate.

Photographers' credits

Ted Mead, January 1994. Myrtle (*Nothofagus cunninghamii*) and Sassafras (*Atherosperma moschatum*) line the Coldstream River. These are the dominant trees in Tasmania's temperate rainforests. The vibrant green ground cover comprises mosses. More than 200 bryophyte species (mosses and liverworts) have been identified in the Tarkine.

Chris Bell, October 2003. Laurel (*Anopterus glandulosus*) and leatherwood (*Eucryphia lucida*), both endemic species with close Gondwanic affinities, in implicate rainforest swamp in the Savage River rainforest corridor. Leatherwood is a flowering tree and the source of Tasmania's famous strong-tasting leatherwood honey.

Ted Mead, January 2004. Grand myrtles (*Nothofagus cunninghamii*) and tree ferns (*Dicksonia antarctica*) in the Sumac rainforest region. The Sumac forest is west of the Dempster Plains and consists predominantly of rainforest with ancient myrtles, leatherwood (*Eucryphia lucida*) and sassafras (*Atherosperma moschatum*). Together, the Tasmanian Wilderness World Heritage Area and the Tarkine region contain the greatest range in floristic and structural variation of rainforest in cool temperate Australia.

Geoffrey Lea, November 2003. Myrtle (*Nothofagus cunninghamii*) trunks in callidendrous rainforest. The fertile basalt soils of the Tarkine give rise to these tall, open rainforests, the finest expression of its type in the world.

Mike Thomas, October 2002. Twin myrtles (*Nothofagus cunninghamii*) in the Tarkine rainforest.

Ted Mead, November 2003. Philosophers Falls where the Upper Arthur River drops sharply over a narrow sluice.

Simon Olding, October / November 2003. Sassafras (*Atherosperma moschatum*) in front of small falls in the Savage River rainforest corridor.

Rob Blakers, October 2003. Tributary of the Upper Rapid River.

Chris Bell, October 2003. Horizontal (*Andopetalum biglandulosum*) and myrtle (*Nothofagus cunninghamii*) rainforest near the Rapid River.

Chris Bell, January 2004. Horizontal (*Andopetalum biglandulosum*) and myrtle (*Nothofagus cunninghamii*) rainforest near Eastons Creek.

Chris Bell, January 2004. Sassafras (*Atherosperma moschatum*) and myrtle (*Nothofagus cunninghamii*) in open callidendrous rainforest near Eastons Creek.

Dave James, December 2003. An endemic strong-billed honeyeater (*Melithreptus validirostris*) in the Whyte River Valley. A gregarious bird, the strong-billed honeyeater is found only in Tasmania where it is encountered mostly in eucalypt-dominated vegetation. It may grow up to 175mm in length and is distinguished by a white band surrounding its head behind the eyes. They are often seen, noisily lifting bark from eucalypts, swinging from bark shreds to remove them and hanging upside down on the bottom side of limbs searching every nook and cranny for grubs and insects.

Dave James, December 2003. Button grass flowers on Badger Plains / the Longback. Button grass (*Gymnoschoenus sphaerocephalus*). Button grass is not a true grass, but a sedge. It is easily identified by the spherical seed heads at the end of long stems that remain on the plant long after flowering. It is typically found on low-fertility, peat soils and is often advantaged in space and time by burning of the sedge and heathlands in which it is often the dominant plant.
'They seemed like old friends, laughing in the northerly breeze.'

Rob Blakers, 1994. Morning light across the plains to the east of the Norfolk Range, north of Mount Bolton.

Rob Blakers, 1994. Morning light across the plains to the east of the Norfolk Range, north of Mount Bolton. The rare and endangered orange-bellied parrot (only 200 birds remain) breeds in southwest Tasmania and spends the winter in coastal Victoria and South Australia. Sedgelands such as these provide a food source for these birds during their seasonal migration.

Ralph Ashton, November 2003. The Pieman River from Mount Donaldson.

Loïc le Guilly, October 2003. Rainbow and glow from Mount Donaldson.
'This was an epic shot. Glen Turvey and I were on top of Mount Donaldson to capture the evening light. The light was stunning. But we also had rain and wind hitting us vigorously. It was all worth it when the rainbow appeared behind us. Interestingly the glow in the background seems to come straight from the summit where we were.'

Loïc le Guilly, October 2003. Tarkine sunset over the Norfolk Range from the 'Road to Nowhere'.

Grant Dixon, approx 1990. Perched granite boulder and fire-killed Banksia shrub on the western side of the Meredith Range plateau, near the summit of Mount Meredith. A fire from the Savage River area in 1982 burnt 11,000ha of rainforest, the largest recorded area of rainforest destroyed in a single fire in Tasmania. Amongst the total 48,000ha burnt by this fire was the Meredith Range plateau, including the summit area illustrated.

Chris Bell, 1990s. Red and white lichen on rock along the Tarkine coast. Lichen is not a single organism but a symbiotic relationship between two organisms. Lichens are composed of fungal filaments amongst which live algal cells.

Chris Bell, 1990s. Red and white lichen on rock along the Tarkine coast.

Chris Bell, 1990s. Red, orange and white lichen on rock along the Tarkine coast.

Simon East, October / November 2003. Granite tors at Conical Rocks. Weathering along angulate jointing facilitates the development of the characteristic tors in granite. The bright lichens that cover the weathered rock in coastal areas are also characteristic.

Dave James, November 2003. Eucalypt forest in the Heazlewood Valley. Understorey species in forest such as this include Dogwood (*Pomaderris apetala*), Blackwood (*Acacia melanoxylan*) and shrubby daisies such as Dolly bush (*Cassinia aculeate*), seen flowering in the foreground.

Ted Mead, November 1992. This graceful reach along the wild and remote ravine of the Savage River, clad in dense riparian rainforest, is one of the most aesthetically pleasing places in the Tarkine.

Joe Shemesh, 2003. Smithton peppermint (*Eucalyptus nitida*) at sunset near the Pieman River.

Ralph Ashton, November 2003. Juvenile Tasmanian wedge-tailed eagle (*Aquila audax*). About 100 breeding pairs exist in Tasmania. They have a wingspan up to 2.2 metres, will desert their nests if disturbed and need over 10 hectares of forest. Forestry operations and land clearing continue to remove their habitat.
'As we floated down the Donaldson River, this eagle darted low overhead tracking the river. Then came another. And another. In a flash, the first eagle had plummeted 10 metres into the water a mere boat-length ahead of us. Shocked from its attack by the two older birds, it slowly made its way in a limping butterfly stroke to the shore.'

Kip Nunn, October 2003. *Leptospermum riparium* (tea tree) growing on slate in the Frankland River catchment.

Ralph Ashton, September 2003. Stormy view to the coast from Mount Livingstone.

Andy Townsend, January 2004. Reeds (*Restio sp.*) in the forest edge at Wombat Flats.

Geoffrey Lea, November 2003. Aerial view of backlit rainforest canopy in the Upper Savage River Valley.

Loïc le Guilly, October 2003. Native pigface (*Carpobrotus rossii*) on the Tarkine coast north of the Pieman River heads.
'After an hour spent with my face in the flowers I finally found the right one. The sun was backlighting the petals, revealing the subtle texture of this superb plant.'

Dave James, November 2003. Rainforest at Ahrberg Hill.

Rob Gray, November 2003. A metallic skink (*Niveoscincus metallicus*) on a pandani leaf near the track to Mount Ramsay. Tasmania has 16 species of skinks (*Scincidae*) of which seven are endemic. Tasmania's cool climate makes life more challenging for reptiles, which must absorb outside heat to maintain their bodily processes (ecotherms). In winter, many enter a torpor state.

Rob Gray, November 2003. Pandani (*Richea pandanifolia*) leaf detail on the track to Mount Ramsay. The endemic pandani is actually a giant heath, not the palm it is often mistaken for (especially given the similarity in name).

Geoffrey Lea, November 2003. Aerial view of the Tarkine coast. The Tarkine coast contains a large area of transgressive dunes. These massive and extensive quaternary dunes have undergone several cycles of stabilisation and destabilisation. The present cycle of destabilisation and transgressive dune development began in the nineteenth century as a result of burning and stocking of the dune country. Southern Ocean swells, interrupted at this latitude only by South America and Tasmania, pound this coast incessantly.

Rob Gray, November 2003. Wave hitting granite at Conical Rocks. 'I was viewing the approaching sunlight through the camera, and looking for a better composition with the rock, when whoosh, the wave hit.'

Loïc le Guilly, October 2003. Granite rocks at Conical Rocks. Angulate jointing is clearly visible in the shore platform. Weathering along such joints gives rise to the tors, ribs and slabs characteristic of granite.

Alister Mackinnon, October 2003. Coastal rocks under a rising tide at Sundown Point. The Tarkine's coastal region comprises a diverse array of rock formations. Washing over bull kelp, the ebbing tide rises again over time-smoothed rock surfaces; a constant cycle of ocean weathering over millennia revealing intricate patterns, striations and coloured mineral deposits.

Chris Bell, 1990s. Dystrophic stream near Interview River. Streams flowing from the extensive blanket peatlands of western Tasmania are characteristically stained by tannic acids from the vegetation.

Joe Shemesh, 2003. A giant freshwater crayfish in the Donaldson River. The endangered giant freshwater crayfish (*Astacopsis gouldii*) is endemic to north-west Tasmania. It can grow to a metre in length, but may take up to 50 years to achieve this. Much of its habitat is threatened due to logging operations.

Joe Shemesh, 2003. Rock and lichen at Ordnance Point.

Ted Mead, January 2004. The mid to lower region of the Arthur River in low summer level. The Arthur River is the second largest river in North-west Tasmania and forms the northern boundary of the Tarkine region.

Ted Mead, November 2003. Moss-clad Sassafras (*Atherosperma moschatum*) trees in mist in the Arthur River catchment near Waratah.

Ted Mead, November 2003. An entanglement of horizontal scrub in the Arthur River region. Horizontal (*Andopetalum biglandulosum*) is an endemic understorey species and grows prolifically in wet gullies and on slopes throughout the Tarkine. Amongst bushwalkers it is infamous for its alleged impenetrability.

Chris Bell, October 2003. Myrtle (*Nothofagus cunninghamii*) rainforest near the Rapid River. Myrtle, the dominant canopy tree in most Tasmanian rainforest, is a clear example of the Gondwanan affinities of many species in the area. *Nothofagus* species occur in New Zealand, New Caledonia, Patagonia (South America) as well as eastern Australia.

Ted Mead, November 2003. Looking up into the canopy of myrtle-dominated (*Nothofagus cunninghamii*) rainforest on the edge of the Netherby Plains.

David Stephenson, January 2004. Stringybark gum located near John Lynch Creek in the Huskisson River Valley.

Loïc le Guilly, November 2003. Native pigface (*Carpobrotus rossii*), Tarkine coast near Rupert Point, north of the Pieman River.

Rob Blakers, 1994. Aerial view of interlocking spurs in the middle reaches of the Savage River.

Rob Blakers, January 2004. Tall forest above the Middle Rapid River.

Kip Nunn, October 2003. Mother shield fern (*Polystichum proliferum*) amongst younger myrtle (*Nothofagus cunninghamii*) trees and a browntop stringybark (*Eucalyptus obliqua*) east of the Frankland River in the north of the Tarkine.

Joe Shemesh, 2003. Tasmanian tree frog (*Litoria burrowsae*) on reeds (*Restio sp.*) at Rupert Point. This is one of eight frog species recorded in the Tarkine.

Al Dermer, January 2003. *Gahnia grandis* (cutting grass) near the Savage River. Cutting grass is a common large tussocky plant with plume-like flowering heads to 3.5m overall. Leaves are grass-like with a sharp cutting edge. Flowers are bright brown, flowering in late spring and summer.

Andy Townsend, January 2004. Sunset at Mount Donaldson.

Geoffrey Lea, November 2003. Aerial view of mist in eucalypts, towering above the rainforest canopy in the ridge between the Donaldson and Little Donaldson Rivers, 6 kilometres northeast of their junction.

Ted Mead, December 2003. Sunrise over upthrust sandstone beds that comprise the steep rocky spine of Mount Pearce with dense fog filling the Netherby Plains region.

Ted Mead, December 2003. Dusk on Rocky Sugarloaf. There are no true alpine environments in the Tarkine, but this 920m summit comes close and is an environment where a number of endemic plants exist.

Kip Nunn, 1995. Heathland spurs looking east towards Mount Balfour from the Falkland Range.

Rob Blakers, November 2003. Morning mist in the upper reaches of the Little Donaldson River, south of Mount Bertha.

Simon East, October / November 2003. Exposed gravely soil after burning of button grass and peat adjacent to Lake Pieman. High-intensity fires, or fires when the soil is dry, burn the peat soil as well as the vegetation. In western Tasmania the then-exposed gravely substrate contains few nutrients. Recovery can therefore be slow and the resulting vegetation rather depauperate.

Ted Mead, November 1996. Midden shell dunes near Ordnance Point are testament to the long Aboriginal occupation of the Tarkine coastline. Aboriginals occupied the Tarkine coast for several thousand years until the 1830s. Many modern-day Tasmanian Aboriginals still retain a strong connection with the region.

Ted Mead, December 2003. Weathered coastline is testament to the wild ocean forces that batter the western extremities of the Tarkine.

Ralph Ashton, March 2004. Evidence of recent bushfires on the Tarkine coast north of the Pieman River.

Chris Bell, October 2003. Fallen logs and last season's and new season's fern in the Savage River rainforest corridor. The invertebrate fauna in wet forest habitats is diverse and includes many species of Gondwanan descent. Rotting logs, moss-covered substrates and leaf litter are important microhabitats for many such species.

Rob Blakers, October 2003. Buttress of Myrtle (*Nothofagus cunninghamii*) tree in the Upper Rapid River catchment.

Rob Blakers, 1994. Rainforest in the middle reaches of the Savage River.

Geoff Murray, November 2003. Swamp paperbark (*Melaleuca ericifolia*) near Temma.

Simon Olding, October / November 2003. New growth on young myrtle (*Nothofagus cunninghamii*) in the Savage River rainforest corridor.

Ted Mead, November 1996. Native pigface (*Carpobrotus rossii*) beneath sculptured granite tors near the Pieman River heads. Common along the sandy coastline, the fleshy leaves of pigface allow it to survive this desiccating environment and its bright pink flowers provide splashes of colour during early summer.

Peter Dombrovskis, 1992. Coastline north of the Pieman River.

Ted Mead, December 2003. Veteran logs swept downstream from the Arthur River during flood have been gathered by wild ocean swells and heaved onto the rocky platforms of the coastline.

Alan Moyle, November 2003. Huon pine (*Lagarostrobus franklinii*) along the Pieman River near Corinna. The Tarkine contains the northern limit of the range of this endemic species, once widespread across Australia in Gondwanan times. Huon pine is an extremely durable wood (it does not rot or decay once dead) explaining its attraction for early boat builders and therefore its extensive past logging from western Tasmanian rivers.

Alan Moyle, November 2003. Coastal rocks on the Tarkine coast, polished by eons of wave-induced movement.

Ted Mead, November 1996. Ancient circle engravings (petroglyphs) from Aboriginal people can be seen along the coastal rocky areas of the Tarkine.

Rob Gray, October 2003. Thinly-bedded quartzite and pebble beach, polished by eons of wave action near the Pieman River Heads.

Glen Turvey, October / November 2003. Sunset out to sea from Mount Donaldson.
'The light did many magic things that night. This was one of them…'

Rob Gray, October 2003. Storm clouds on the 'Road to Nowhere', near Mount Vero.

Ted Mead, December 2003. A half moon at dusk looms over the quartzite crags looking towards Mount Cleveland in the western distance.

Simon Olding, October / November 2003. Early morning looking north in the Savage River rainforest corridor.

Mike Thomas, January 2004. Tarkine Falls (named by the photographer in 2002), cascading over basalt columns in Eastons Creek. Basalt lava flows blanketed north-west Tasmania during Tertiary times (20-30 million years ago) and now form extensive plateaux. The basalt gives rise to very fertile soils, the basis of much of north-western Tasmania's agriculture. In the Tarkine, basalt underlies extensive rainforest areas and the fertile soils have facilitated the development of grand, tall and open myrtle-dominated rainforest.

Anah Creet, January 2000. Cyclonic Sea. Sandy Cape.

Anah Creet, January 2000. Wallaby tracks criss-cross dunes above a hidden wetland near Symes Creek at Driftwood Cove north of Sandy Cape. Mammals in the area are generally most active at night. These tracks are evidence of their feeding wanderings preserved on the dunes the following day.

Rob Gray, October 2003. Common wombat (*Vombatus ursinus*) on a coastal track north of the Pieman River. The wombat is the largest burrowing mammal and is widespread in Tasmania, occurring from sea level to alpine areas. Native grasses are the wombat's prime food. They are mostly nocturnal and graze 3 to 8 hours per night, perhaps travelling many kilometres while doing so.

Ted Mead, November 2003. The vibrant red flower of the endemic Tasmanian Waratah (*Telopea truncata*) on the Netherby Plains. It prefers the moist basaltic soils, blooms in spring and early summer and can grow to a small tree given the absence of fire.

Grant Dixon, January 2004. Magnesite rock near Lyons River. Magnesite is a carbonate rock that occurs as lenses within the Arthur Metamorphic Complex that traverses the Tarkine region. Magnesite is subject to the development of karst features (caves, surface depressions, pinnacles, etc.). These features are globally rare and those in the Tarkine are the best examples in Australasia. The karst features probably developed some 30 million years ago, were subsequently buried and are now being exhumed by ongoing processes of erosion.

Ted Mead, December 2003. Native laurel (*Anopterus glandulosus*) below Mount Ramsay. This plant is a Tasmanian endemic with strong Gondwanan affinities that thrives as an understorey species in wet forests. It flowers for a brief period in spring.

Geoff Murray, November 2003. Guthrie Creek on the Heemskirk Road near the beginning of the Mount Donaldson track.

Ted Mead, November 1996. The fruiting head of Scoparia (*Richea scoparia*) on Mount Cleveland. A Tasmanian endemic common in alpine and sub-alpine regions. A few small patches are located on peaks within the Tarkine region.

Geoff Murray, October 2003. Longback Creek.

Rob Gray, October 2003. Mushroom near the Savage River. Fungi, on the forest floor, fallen logs, standing trees and elsewhere, are an important part of the rainforest ecosystem.

Ted Mead, November 2003. A river tea tree (*Leptospermum riparium*) growing amidst the Donaldson River. The Donaldson River catchment is one of the most pristine reaches of the Tarkine and consists of almost entirely cool temperate rainforest.

Rob Gray, November 2003. The saltspray plantain (*Plantago triantha*) at Conical Rocks. Saltspray plantain grows on coastal rocks and in areas subject to salt spray. Its succulent and hairy leaves allow it to survive the dessicating conditions in the salt spray zone.

Alan Moyle, November 2003. Philosophers Falls glimpsed through ferns and trees of the surrounding rainforest.

Ted Mead, January 2004. Lake Chisholm, surrounded by mixed forest, is a natural lake filling a large karst depression in dolomite bedrock. It is a sanctuary for the endangered giant freshwater crayfish (*Astacopsis gouldi*). Extensive areas of north-west Tasmania are underlain by carbonate bedrock, mostly dolomite, within which karst features such as caves and dolines (depressions) develop as a result of solution of the rock by groundwater. Much of this karst country lies north of the Arthur River, but extends south in the Lake Chisholm region.

Andy Townsend, October 2003. Lovers Falls on the Lower Pieman River.
'This was a little gem to discover and required some delicate climbing up slippery logs to get to. It was well worth the effort though.'

Andy Townsend, January 2004. Wes Beckett Falls in the Wes Beckett Reserve near the Arthur River.

Ted Mead, November 2003. A steep-sided, fern-lined rainforest ravine in a tributary to the Arthur River.

Grant Dixon, 1985. Incised valley of the Lagoon River, with the Norfolk Range beyond from the Lagoon River Valley several kilometres inland from the coast. The Tarkine's coastal rivers have cut deep V-shaped valleys into the coastal plateau, itself an old planated erosion surface.

Loïc le Guilly, December 2003. Tarkine rainforest canopy.

Ted Mead, August 1990. Dramatic valley mist in the morning wafts through the forested valley of the Hellyer River.

Joe Shemesh, 2003. Eucalypt towering over rainforest in fog near the Pieman River below Corinna.

Simon East, October / November 2003. View of the Arthur River from Sumac lookout.

Shoshanna Jordan, October 2003. Looking into the Tarkine from the Frankland River.

149

Writers' Credits

Where the text that accompanies the photographs has been extracted from a named piece of poetry or prose, the title is given. Otherwise, the text has been taken from untitled writing in response to the Tarkine.

Page 9: Anna Housego

Page 14: Carolyn Fisher, from 'Tree ferns'

Page 20: Glen Turvey, from 'That which is not ours …'

Page 28: Ben Walter, from 'Tarkine diversity'

Page 32, 50, 67, 90, 95, 96, 100, 104, 134: CA Cranston, from the 'Fortnight diaries'

Page 38: CA Cranston and Tim Thorne, from 'Timeless'

Page 42: Glen Turvey, from 'That which is not ours …'

Page 58: Patsy Crawford, from 'The Arthur'

Page 63: David Owen, from *Thylacine: The Tragic Tale of the Tasmanian Tiger* (Allen & Unwin, 2003)

Page 64: Karen Knight, from 'Fighting the currents'

Page 72: Michelle Foale, from 'Friday night'

Page 80: Anah Creet, from 'Sandy Cape: land of spirit'

Page 83: Darvis, from 'Talking with Tarkine'

Page 86: Jarrah Keenan, from 'Mt Ramsey Triptych'

Page 89: Patsy Crawford, from 'The Savage'

Page 107: Mary Jenkins, from 'Hope'

Page 108, 116: Claire Konkes

Page 120: Ben Walter, from 'Off the track'

Page 123: Sue Moss, Julie Hunt and Angela Rockel, from 'Rivertalk'

Page 128: Carolyn Fisher, from 'The myrtle tree'

Page 137: Anna Housego

BIOGRAPHIES

Ralph Ashton
Ralph grew up in Papua New Guinea and currently lives in Sydney where he works as a landscape conservation adviser for WWF, concentrating on Tasmania. Before that, he was a mergers and acquisitions lawyer and then investment banker in Melbourne and Sydney. His interest in photography was acquired at an early age and has developed through travel and time. Introduced to bushwalking as a teenager in the Victorian high country, he has maintained his love of wild places ever since. He has held exhibitions of his industrial and wilderness photography in Melbourne and Sydney, and his illustrated articles have been published in Qantas's in-flight magazine. He uses a Nikon F80 and D100 and an assortment of Nikkor lenses. <www.perspectivecontrol.com>

Chris Bell
Chris came to Tasmania in 1972 to join the campaign to save Lake Pedder from destruction and has been there ever since. A founding member of the Tasmanian Wilderness Society and the Tasmanian National Parks Association, he remains deeply committed to the preservation of the natural world, particularly that in Australia. A passionate photographer, he has had four books published: *A Time to Care – Tasmania's Endangered Wilderness*; *Beyond the Reach – Cradle Mountain–Lake St Clair National Park*; *The Noblest Stone: Carnarvon National Park* and *Primal Places: Tasmania*. Chris's work has been widely published, particularly in Japan and Europe where he was invited on two occasions as a guest speaker to the Vargarda Photo Festival in Sweden. 'Within all my images is the unspoken message that humans desperately need to re-establish the bonds with nature that are continually being severed. There is no future otherwise.' Chris's images were taken with a 4x5 Linhof Technikardan folding monorail camera, using 65 mm, 75 mm, 90 mm and 150 mm lenses.

Rob Blakers
Rob grew up in Canberra and began bushwalking in high school, and cross-country skiing during a zoology degree at the Australian National University. Upon completing university in 1980, he travelled to Tasmania for a three-week cross-country skiing holiday and stayed to work with the Tasmanian Wilderness Society in the campaign to prevent the damming of the Franklin River. Images from Rob's collection have been used extensively for nature conservation, and in a wide variety of publications including books, posters, cards, calendars and diaries, and in magazines ranging from *New Scientist* to *Outdoor Australia*. Rob uses view cameras: a medium format (6x9 cm) Horseman, and a large format (5x4 inch) Ebony with Nikkor and Schneider lenses, ranging from 65 mm to 300 mm. <www.robblakers.com>

CA Cranston
CA Cranston lives in Tasmania, is interested in nature writing and bushwalking.

Patsy Crawford
Patsy is a Tasmanian journalist and writer. She is the author of *King. The Story of a River*, an environmental history (Montpelier Press, 2000) and *God Bless Little Sister*, a novel set against the 1912 North Lyell mine disaster (Red Hill Books, 2004). She co-wrote *The Slumbering Giant*, an industrial and social history of the Renison tin mine (Renison Limited, 1996). She has walked in the Tarkine.

Anah Creet
Anah lives in Hobart with her young family. She is a Fine Arts graduate from the University of Tasmania. In 1999, she received a Wilderness Arts Residency grant from Arts Tasmania for her photography. She lived on the Tarkine coast for two months collecting images and sound recordings. In 2000, Anah was awarded the Evolution Art Prize in Queensland, for an audio-visual on the Tarkine. Her camera is a simple Canon A1 with various lenses. Anah is currently working on photographic/mixed media illustrations for a book.

Mark Davis (Darvis)
Darvis was born in Launceston, where a conservative upbringing resulted in the exploration of an alternative life perspective during his late teens. This exploration led to a profound sense of connection with and deep love of the Tasmanian landscape. This love in turn led to the co-creation of an eco-tourism bushwalking business (Tiger Trails) that focusses on introducing people to threatened landscapes, including the Tarkine. Through this work he gains immense inspiration and deep satisfaction. It is from this place and love that his music springs forth.

Alistair Dermer
Alistair was born in a small country town in north-east Victoria and studied a Bachelor of Applied Science, majoring in Eco-tourism and Protected Area Management. He then spent two years in Western Australia managing bird observatories before moving to Tasmania at the beginning of 2000 where he supervises environmental programs and works as a consultant to the Nature Conservation Branch of the Tasmanian Department of Primary Industries, Water and the Environment. Alistair spent six months at Macquarie Island over the summer of 2001/2002. He received the Premier's Dombrovskis Award in 2002. He uses a Pentax 6x4.5 medium format camera with a 75 mm lens with +3 close-up ring.

Grant Dixon
Grant trained as a geologist and now works part time for the Tasmanian Parks and Wildlife Service. He spends part of each year trekking, climbing, skiing and photographing wild and remote areas of the planet. Grant's photographs and illustrated articles have appeared in magazines, books and other publications internationally. He has recently co-authored trekking guides to the South American Andes and European Alps. Grant won the 1997 Escalade Nikon Mountain Photographic Competition and was runner-up in 1999. In 1998 Grant travelled to Antarctica as a photographer for the Australian Antarctic Division. He uses a lightweight medium format camera (Mamiya 7) for some of his landscape work but favours various combinations of 35 mm equipment for travel, adventure and wildlife photography. <www.view.com.au/dixon>

Peter Dombrovskis
Peter was born in a German refugee camp after World War II to Latvian parents. He emigrated with his mother to Tasmania in 1950, where – as a teenager – he met Olegas Truchanas, a conservationist and photographer of Lithuanian descent, who became a father figure and mentor to him. Peter's work has been published extensively in books, calendars, cards, posters and magazines, and is represented in numerous galleries and collections around the world. He used a large format Linhof Master Technika 5x4 inch flatbed field camera and three lenses: a 90 mm Nikkor F4.5, a 300 mm Nikkor MF9 and a 150 mm Schneider Symar-S. Peter died while photographing the south-west of Tasmania in 1996. In 2003, he became the fifty-eighth (and only Australian) inductee into the International Photography Hall of Fame in Oklahoma, USA. <www.view.com.au/dombrovskis>

Simon East
Simon started photographing the landscape as a means of sharing his adventures in the Tasmanian wilderness with friends and family at home. He takes pleasure in using hand-made and restored cameras, some of which are over one hundred years old. When taking photos, he takes particular interest in the unique geology of the Tasmanian landscape. Simon uses a Nikon F80 with 50 mm lens, a Kowa 6x6 medium format with an 85 mm lens and a Linhof 6x9 field camera (that he has reconditioned) with a 150 mm lens.

Carolyn Fisher
Carolyn moved to the north-west coast of Tasmania eleven years ago. Originally from the UK, she lived and worked as a physiotherapist in various corners of the world including Malawi and Saudi Arabia. Her poems have been published in literary magazines both in Australia and overseas, and she has been a recipient of Arts Tasmania and Australian Council grants to assist her in working towards her first collection of poetry.

Tim Flannery
Tim is a scientist, explorer and writer. An internationally known expert on the causes of extinction, his views on environmental sustainability and population are widely sought. He is the author of several books including *The Future Eaters*, *Throwim Way Leg* and *The Eternal Frontier*. In 1998–99 he was professor of Australian Studies at Harvard University, where he taught ecological history. Tim lives in Adelaide, where he is director of the South Australian Museum.

Michelle Foale
Michelle lives in Burnie, in north-west Tasmania, amongst friends dedicated to the protection of the Tarkine. She plans to dine al fresco on the former site of that town's woodchip pile with her son Sam within the decade. To this end, she is a wildlife tourism operator and conceives of things to write, usually on the inside cover of whatever field guide is in her raincoat pocket at the time.

Rob Gray
Rob has travelled widely, to destinations including Tahiti, Panama, USA, UK, Europe, New Zealand, Africa and most of Australia. He worked as a photographer in London, Canberra, Perth and Grafton, and belonged to Globe Photos, a New York stock library. He wrote and photographed travel articles on subjects such as London, Paris, African wildlife and bushwalking. In the 1990s Rob exhibited, ran workshops, and sold prints from his gallery in Canberra. In 2000 he left his job, closed the gallery, sold most possessions, and started life on the road. Rob now spends his time exploring and photographing Australia. He uses Canon F1N bodies with 14/2.8, 24/1.4, 50/1.8, 85/1.2, 135/2, 200/2.8 and 300/2.8 Canon FD lenses and a Tachihara 5x4 inch field camera with 90 mm Nikkor and 210 mm Schneider lenses. <www.robgray.com>

Anna Housego
Hobart based, Anna can't remember a time when she hasn't been writing. She has made a living from it, one way or another, for twenty-five years. A former journalist and author of two published histories, she is a freelance writer who works with print and visual media, and specialises in developing communications strategies.

Julie Hunt
Julie Hunt lives near Cygnet in Tasmania. Her poetry has been published in many journals. She has published two children's books: *Away away!* (Roland Harvey Books, 2000) and *The Answerman* (Hyland House, 1991). She is now illustrating her third book, *The Coat*. She holds a Diploma in Professional Writing and Editing (RMIT) and works as a graphic designer.

Dave James
After a transcendent childhood of chasing animals and climbing trees, somehow Dave convinced the government to pay him to chase animals and climb trees. As an adult he prefers childhood but finds occasional solace in working with Tasmania's threatened fauna. Chronic daydreams and lazy idealism push Dave towards the photographic world while nostalgia, delusion and a thousand dirty habits incline him to focus on nature subjects. He uses a now-battered Nikon F70 SLR body and enjoys a range of lenses from 18 mm to 400 mm.

Mary Jenkins
Mary was born in England of Welsh parents. After living in various northern hemisphere countries she moved to Sydney where she started her academic studies, completing a PhD in Environmental Studies at seventy after a move to Tasmania. She has been writing and publishing poetry and prose since then.

Shoshanna Jordan
Shoshanna is a Melbourne-based photographer undertaking further studies at RMIT University. Her interest in the environment was rekindled after walking Tasmania's Overland Track from Cradle Mountain to Lake St Clair in February 2000. She sees the fading moment as a metaphor for life and the need to honour and nurture conservation. Her work is held in private collections both locally and internationally, and has been used in publications. She uses a Hasselblad 500CM with a 50 mm f4 lens.

Jarrah Keenan
Jarrah arrived in Tasmania in 1995 to help in the campaign to stop the 'Road to Nowhere' being driven through the Tarkine. Since then, he has been a fervent defender of the Tarkine through, amongst other things, his work with Tiger Trails. Guiding people through Tasmania's wild places is his unbridled passion in life – he's just celebrated his 400th night and fortieth birthday double and shows no signs of slowing down!

Karen Knight
Karen is an accomplished poet, performer, competition judge and editor whose creative life spans more than thirty years. Her work has been widely published in literary journals, anthologies and newspapers throughout Australia, America and the United Kingdom. Karen regularly performs her work at festivals, in cafes, pubs, art galleries, museums and on buses. Her collections include *Singing in the Grain* (Walleah Press) and *Now My Mother Has Become* (Picaro Press). Karen works for the Australian Red Cross in Hobart.

Claire Konkes
Claire first visited Tasmania in 1995 and quickly became involved with the so-called 'Tarkine Tigers' in the campaign to stop the 'Road to Nowhere' being cut through the centre of the Tarkine. Claire has undertaken many trips into the Tarkine rainforests, discovering the magic to be found in wild places. After reporting for *The Australian* in Sydney and Hobart, Claire now lives on the Tasmanian east coast working as a freelance journalist and novelist.

Loïc le Guilly
Loïc is a French photographer who moved to Tasmania after falling in love with a devil. After working as a photojournalist in Europe (with press agency Gamma) and as a commercial photographer in his early years in Australia, he now focusses on nature photography in Tasmania. Loïc also runs a web and multimedia business specialising in virtual tour production (based on interactive 360° panoramas). He uses a Silvestri 5x4 and Nikon 35 mm cameras. <www.lophoto.com> and <www.ultimedia.com.au>

Geoffrey Lea
Geoffrey was born Sydney and has lived Hobart since 1979. He is married with one child. He was an executive officer of the Tasmanian Wilderness Society during the Franklin Campaign in the 1980s. He has been a professional photographer since 1988. He works as an advertising photographer and publishes his own landscape work in a range of posters and postcards. On-ground shots were made with Linhof Technikardan 23 (folding monorail view camera) with Schnieder 57 mm, 105 mm and Nikkor 200 mm lenses. Aerials were with Fuji GSW and GW 690 6x9 cm rangefinder cameras. <www.geoffreylea.com>

Alister Mackinnon
After travelling around Australia, Alister specialised in land and water project management for two years in Kununurra, Western Australia. His initial passion for photography further developed while exploring stone megalithic sites throughout Western Europe, endeavouring to capture the pure aesthetics of ancient landscapes, environmental art and design and our interconnectedness with nature. Alister works in Tasmania in cinematography, environmental management and stone sculpting. He uses a Pentax ESPIO 120SW wide angle lens.

Ted Mead
Ted is a Hobart-based artist and naturalist who has explored extensively throughout the remote areas of Australia. For Ted, nature and the outside world have been constant companions since childhood. Ted claims that his photographic vigour stems from the inspiration of the living planet, and the urgent need to protect such priceless environments. Commitment to the conservation of wild places has been the driving element behind much of his photography. Ted strongly believes that it is essentially the evocative image captured on film that motivates public support for the preservation of our remaining primitive world. Ted's landscape photographic equipment consists of an array of large format cameras including a Linhof 6x17 cm panoramic camera and a Horseman 4x5 flat bed field camera with Nikkor and Schneider lenses. <www.tedmead.com>

Sue Moss
Sue Moss lives in southern Tasmania surrounded by a wet sclerophyll forest. Her poetry and performance pieces have been published by New York University Press (2001), Sybylla Feminist Press (1996), Penguin Australia (1994) and Picador (1993). Her most recent publication is *Interior Despots: Running the Border*, co-edited with Karen Knight and published by Pardalote Press (2002). She is a Tasmanian reviewer for the national on-line arts paper *RealTime*.

Alan Moyle
Alan has a passion for capturing moments on film be they landscapes of the Tasmanian wilderness, or the facial expressions of comedians. His images have been exhibited around Australia and published in many magazines. Alan is a past winner of the Dombrovskis Award for nature photography, and was one

of the contributors to the *Landscapes* book and exhibition in 2002. He uses a Nikon F90x and Olympus OM1 with a variety of lenses. <www.photobat.net>

Geoff Murray
Geoff lives in the Lachlan Valley with his wife Lyn. He has been photographing since the late 1980s, initially with a Nikon F90, then a Mamiya 7, and now a Horseman 6x9 view camera. His photographs have been published in calendars, magazines, books and diaries in Australia and overseas. He concentrates mostly on wilderness images but some general landscape photography as well. Seeing the beauty of Tasmania as he photographs it has instilled a strong conservation ethic in Geoff. Geoff uses a Horseman ER1 6x9 medium format view camera with a variety of Schneider and Nikkor lenses. <www.geoffmurray.com>

Kip Nunn
Kip was born in Launceston, grew up on the north-west coast of Tasmania and now lives at Coles Bay. He acquired his love for photography through his father. After living at Marrawah for twenty years and having friends living at Balfour, the Tarkine has long held a fascination for Kip. He has self-published a successful pictorial booklet on the Freycinet Peninsula, along with postcards of the area. Nature and landscape photography are Kip's passions; he also does some commercial work. He currently uses a Nikon FM2, FM and D100 and a Fuji GSW690III 6x9. <www.tasmanianphotography.com.au>

Simon Olding
Simon was born in Hobart into a bushwalking family and was exposed to photography as a teenager. He moved to Melbourne to study scientific photography at the Royal Melbourne Institute of Technology in 1988. After graduating in 1990, he began work for Monash University Medical School. He spent a year in Canada before returning to Melbourne to work for The Walter and Eliza Hall Institute. He currently lives and works in Hobart, looking after two children. He works primarily in large format with a 4x5 Zone VI field camera and a range of Schneider lenses, and also in 35 mm with a Nikon FM2 and 105 mm and 300 mm Nikkor lenses. <www.iccimagetec.com.au>

David Owen
David is the editor of Island magazine. His book *Thylacine: The Tragic Tale of the Tasmanian Tiger* is published in Australia by Allen & Unwin (2003) and in the US by Johns Hopkins UP. His latest book is *Tasmanian Devil* (Allen & Unwin, 2004).

Robert Purves
Robert is a businessman, grazier and conservationist. He has been president of the WWF in Australia since 1999, Trustee of the Lizard Island Research Foundation and a member of Environment Business Australia's National Advisory Group. Robert is also chairman of health services company DCA Group Limited, which is involved in radiology and aged care, and has been a director of a diverse number of public companies. In addition, Robert is a council member of the State Library of NSW. He owns two grazing properties in the southern tablelands of NSW and in 2004 announced the establishment of the Purves Environmental Fund.

Angela Rockel
Angela Rockel lives at Silver Hill, south of Hobart.

Joe Shemesh
Joe has specialised in nature photography for more than a decade. Since moving to Tasmania in 1994, he has undertaken major photographic assignments for a variety of clients including the Australian Tourist Commission, Tourism Tasmania and *Australian Geographic*. More recently, Joe has combined his photographic talents with nature-based film-making, producing among other things a short film featuring the majestic beauty of the Tarkine. Joe uses a Pentax 6x7 with a range of lenses including 45, 105 and 300 mm, and a Canon EOS3 with a range of lenses including 21, 35–105 and 400 mm. <www.storm-front.com.au>

David Stephenson
David Stephenson moved to Hobart in 1982, where he now heads the photography program at the University of Tasmania's School of Art. His work has been exhibited widely and acquired for many public and private collections, including the National Gallery of Australia, the National Gallery of Victoria, the Art Gallery of New South Wales, and New York's Metropolitan Museum of Art. He used a Hasselblad Superwide C, 38 mm Zeiss Biogon. <saulgallery.com/stephenson/stephenson.html> and <bettgallery.com.au/dstephenson/index.htm>

Mike Thomas
Mike has a passion for river journeys, language, world exploration, and cooking from first principles. He has recently pioneered a multi-day walk in the Tarkine rainforest while working as an emergency medical officer in Northern Tasmania. Mike also helped shape Doctors for Forests and has a prominent role in the local Tarkine campaign. He uses a Canon EOS 500N with 24–55 mm and 75–300 mm lenses.

Tim Thorne
Tim was born in Launceston and has lived in Tasmania for most of his life. He is currently managing editor of Cornford Press. He has been writer-in-residence with a number of organisations, including the Miscellaneous Workers Union and the Queen Victoria Museum and Art Gallery, and has worked as a poet in schools, universities and prisons. He is the author of eight collections of poetry and editor of three anthologies, and his poems have appeared in twelve Australian anthologies and most major Australian journals. His latest book, *Head and Shin*, is published by Walleah Press (2004).

Andy Townsend
Andy first started taking photographs while travelling around Australia in 1994. His photographs have been published in calendars and diaries throughout the world. He has had three successful exhibitions in Hobart and Melbourne and received a Highly Commended prize in the BBC International Wildlife Photographer of the Year award 2003. Andy is a keen environmentalist and combines his passion for photography with kayaking, walking and skiing. He has travelled and photographed extensively in Australia, New Zealand, USA, Canada and Antarctica. Andy has a degree in computer science and currently works at the Australian Antarctic Division. He uses a Canon EOS 3 body and a Canon 28–135 IS EF lens. <www.ozimages.com.au/portfolio/atownsend.asp>

Glen Turvey
Glen recently returned to Tasmania after working for several years interstate, and left the engineering profession to study eco-adventure guiding. He has a passion for photographing people at defining moments in their experience of Tasmania's wild and lonely places. Glen uses Nikon F60 and F80 bodies with 20/f2.8, 24–70/f3.5-5.6, 75–300/f4.5-5.6 lenses and a Rollei SL66 with an 80/2.8 lens.

Les Walkling
Les is an artist and an educator. Before turning to fine art photography in 1975, he studied science and philosophy. Largely self-taught, in 1981–82 he visited the USA on Australia Council Arts grants, studying and working with Emmet Gowin and Frederick Sommer. Les has exhibited widely and his work is represented in many public collections including: The Center for Creative Photography, Arizona; The Metropolitan Museum of Art, New York; The National Gallery of Australia, Canberra; and The National Gallery of Victoria. He is also Media Arts Program Director in the School of Art and Culture, RMIT University, Melbourne, Australia. <www.leswalkling.com>

Benny Walter
Benny has recently worked as a kitchen hand, music festival car-parker and Christian minister. Amongst these occupations, he has published poetry, articles and short stories in places like *Famous Reporter*, *Togatus* and *Traks* and is a past winner of the Judah Waten National Short Story Competition. He likes to be outside, and is finding himself enjoying the music of Augie March and The Sleepy Jackson quite a lot at the moment, both of which play well in the Tarkine.

Acknowledgements

A large group made this book what it is. Thank you (in rough order of appearance).

Robert Purves — whose brainchild it is — for funding the project, taking a deep interest in the book and assisting with photograph selection. Scott Millwood for ideas, contacts and insights into wilderness and photography's relationship to it, especially in Tasmania. Renée Bilston and Inca Waddell for an introduction to the world of publishing, and Renée for proofing the text. Liz Dombrovskis for early support and access to her late husband's works. Melva Truchanas for initial advice and direction. Alan Waugh at Photo Force. Alastair Graham at the Tasmanian Conservation Trust. Phill, Peter, Leonie and Michael Pullinger and the Tarkine National Coalition for providing background information, a guiding service, accommodation at 'Rivendell' in Burnie and assistance with the Fortnight in the Tarkine, and Peter and Phill together with Matt Campbell–Ellis for checking the text. Cate Weate. Heather Hansen at the Hobart Bookshop, Mary Napier at the Tasmanian Writers Centre, Pete Hay, and Warren Boyles at *40 Degrees South* for a connection to Tasmanian writers. Clive Tilsley at Fullers Bookshop for his interest in the project and an introduction to Tasmanian writers and Allen & Unwin. Sue Hines, Andrea McNamara and the team at Allen & Unwin for sharing our vision for this book. Pat Sabine at the Wilderness Gallery in Cradle Mountain for her enthusiasm, suggestions of photographers and assistance with the exhibitions associated with the book. David Owen at *Island* magazine for an extensive database of writers. Jarrah Keenan, Rob Fairlie, Christoph Farrell and Darvis at Tiger Trails, and Craig Garland with his dinghy, for making the Fortnight in the Tarkine logistically possible. Peter Cosier for his dedication to perfection and his assistance with photograph selection. Helen Gee. David Pullinger and the team at Helicopter Resources for their aerial assistance. All the photographers and writers who took part and contributed their work, especially Rob Blakers, Chris Bell, Ted Mead, Geoffrey Lea, Simon East, Grant Dixon (particularly for invaluable assistance with captioning for the Photographers' Credits) and Joe Shemesh for on-going advice and information. Betty and Jeremy Ashton. The staff at the Tasmaniana Library at the Allport Library and Museum of Fine Art in Hobart. Georgie Stilwell and Loïc le Guilly, and Liz and Mike Bingham, for their hospitality and stories in Hobart. Phil Campbell for his design skills. Les Walkling at RMIT University for adding his extensive technical, historical and curatorial knowledge of photography to the photograph selection and design processes, and providing his digital imaging skills. Isabel Ashton and Lucy Esdaile for their hospitality in Melbourne. Michael Krien. Jon Pitt and Tanya Farrell for their hospitality and transport in Hobart. Alison Fraser for proof printing. Huey Benjamin. Max Angus.

RALPH ASHTON